MW01132536

15 MINUTE ART
PAINTING

HANNAH PODBURY

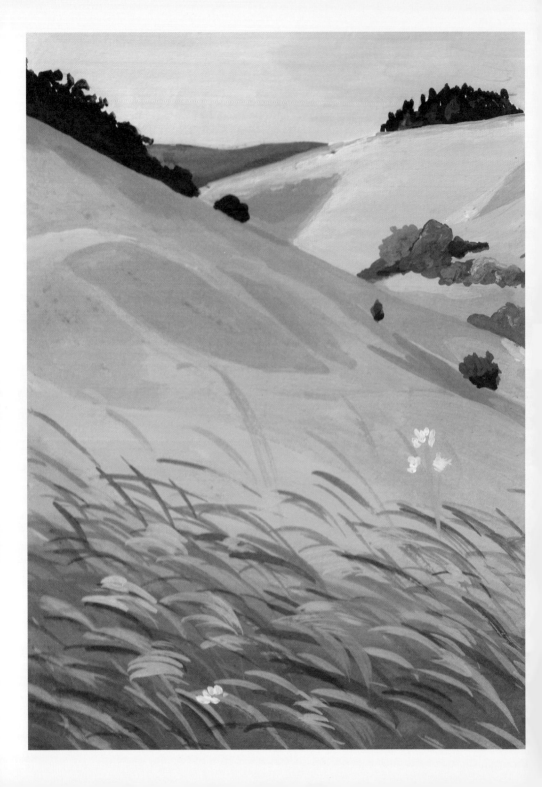

15 Minute Art

Painting

HANNAH PODBURY

Hardie Grant

BOOKS

THIS JOURNAL BELONGS TO

- -

THE PROJECTS

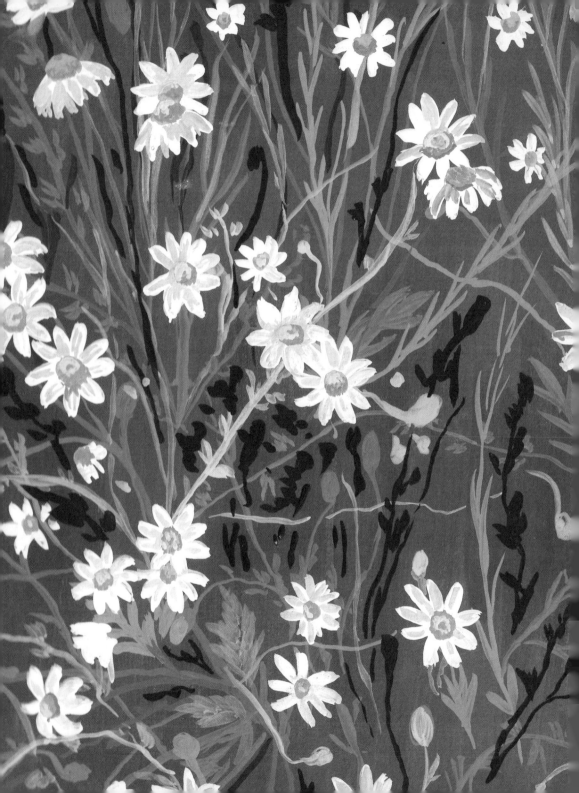

Hello and *Welcome*

My name is Hannah Podbury, and I'm a Social Media Manager and gouache artist based in the UK.

I usually always introduce myself as a Social Media Manager first, rather than an artist, because I only started painting in the summer of 2020. So, calling myself an artist still feels incredibly new to me.

Like a lot of people during the pandemic, I found myself suffering from increasing anxiety, wondering how on earth I was going to keep my small business afloat. My partner was made redundant during the first two weeks, and my initial foray into the world of freelancing suddenly seemed incredibly unstable.

After a few weeks in lockdown, I naturally found myself longing for the one hour a day we were allowed out to exercise. Those 60 minutes of solace eventually led me to pick up a paintbrush and start documenting the wonders I was seeing out on my walks.

I've always been at home in nature, but it was being stuck indoors during lockdown that truly made me appreciate the time I could spend outdoors. I started to notice every new unfurling leaf and the slight changes in the seasons. My immediate surroundings – not just the forest, meadows and beautiful hedgerows, but also the wildflowers and poppies finding life in cracks in the pavings or ivy overtaking a derelict building – were suddenly so interesting and beautiful to me that I couldn't wait to paint them!

At first, I used whatever materials I could find around the house, and just hoped for the best. Old tubes of half-dried-up acrylic and some scrubby paintbrushes that looked like they'd never been cleaned did the job until I was able to order a basic set of gouache paints and a little tiny sketchbook. The rest, as they say, is history.

A few paintings in, I started the 100-day painting challenge, mostly in the form of teeny, double-page sketchbook spreads, sharing my art highs and lows with my small Instagram community. Since then, as more of you have joined me on my journey, I've had questions about how to get started with gouache, and I'm delighted to have the opportunity to share everything I've learnt so far. Hopefully, this will inspire you to pick up a paintbrush, too!

I've come to love the meditative aspect of painting. It's the few minutes a day that I have to myself, not only as downtime, but also as time to develop my creativity and push my artistic boundaries.

In my opinion, there's no such thing as 'bad' art. We are all creative beings, and we all have something new to bring to the art world – whether we are seasoned painters or complete beginners. There is no right or wrong way to paint. In fact, 'mistakes' (if there are such a thing) are part of what hones our skills and help us to develop our unique style. I believe the best way to develop any sort of artistic flair is to just experiment and work with your imperfections. I want to help encourage you to loosen up and bring your own style to your artwork.

In this book, you'll find 50 nature-inspired projects, which can all be completed in six steps or less. I've designed them so they can be finished in around 15 minutes, but there is also the flexibility to spend as long or as little on each painting as you like; it's completely up to you and how you're feeling at the time.

I flit between painting in a photo-realistic and a more illustrative way, so the projects reflect a little of both styles. About 70 per cent of the artworks you'll create were my first time painting them, so not only is this sketchbook a creative journey for you, but it is for me, too!

Each project has practice pages as well as templates to help you get over any fear of the blank page. I've also included colour swatches to guide you when colour mixing. Remember: this is YOUR sketchbook, so feel free to dab paint wherever you fancy, doodle in the margins, make notes if you feel like it, but most importantly – have fun!

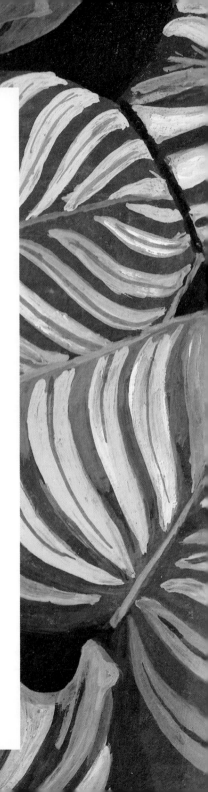

Tools and

Materials

When I first starting painting, I was using whatever materials I had lying around.

A few tubes of acrylic and gouache left over from my time at university, some old paintbrushes and a saucer for a palette. Since then, I've invested in a few brands which have become my staples and are used throughout the book.

If you don't have exactly the same brand or shades I use here, don't worry! We'll mostly be working with primary colours (with the exception of some different shades of green), but it's possible to mix very similar shades from scratch. Head over to the Colour Story (see page 14) to find out how.

From my first experiments with gouache, I knew it was the medium for me. It is often referred to as an opaque watercolour, but I find it behaves very differently, and like to describe it as midway between watercolour and acrylic. Like watercolour, it can be diluted and used in thin washes. However, if you add less water (which is how I tend to use it), it becomes more opaque and can be layered from light to dark or dark to light.

As you can layer gouache paint, it's much more forgiving than watercolour, so is great for beginners or those worried about making 'mistakes'. One thing to note, though, is that, unlike acrylics, gouache is resoluble. In other words, adding water to gouache reactivates it. As a result, it's important to allow drying time in between layers to avoid your painting looking 'muddy'. Gouache also changes value from wet to dry – typically, light values tend to dry darker and dark values tend to dry lighter – so it's often helpful to test darker and lighter colours on scrap paper first to see how they behave.

Despite this, there are so many positives to using gouache. Old tubes and pots of gouache can be reactivated, so paint does not go to waste, layers tend to blend seamlessly and the colours are beautifully rich and vibrant.

GOUACHE

Winsor & Newton is the first brand of gouache I ever tried. The colours are amazing, the texture is smooth and buttery and the paints don't require a lot of diluting.

If you're pushed for time, buying premixed shades is a great alternative, but, if you're able to, I always recommend mixing your own. It teaches you so much more about colour combinations and complementary colours, and really helps you become more familiar with your paints. For more advice on mixing, head to pages 14–15.

If you're not keen on using gouache paint, acrylics are a great alternative for the projects in this book.

PAINTBRUSHES

I tend to use the Pro Arte Scholar Sablene round brushes, which are great value for money, free from animal products and come in a wide variety of sizes. Made from graded and blended synthetic hair, they feature twists, turns and scales that allow them to mimic the properties of natural hair. I'm yet to experience any moulting or splitting and they're great for fine details. Each brush is numbered, which denotes its size. The smaller the number, the finer the brush.

I recommend getting a few different sizes. I mostly use sizes 1 to 6 for the paintings in this book.

Feel free to test your paintbrushes on any of the practice pages in this book. Applying pressure to your brush in different ways alters the brushstrokes. For example, applying greater pressure and almost flattening the bristles along your page creates thick, fanned brushstrokes, while painting with the tapered end creates finer strokes that are easier to control.

Try not to focus on just moving the wrist; instead imagine the brush as an extension of your arm. This helps to create more fluid lines.

We'll be using round brushes for the projects throughout this book. Round brushes are great for smaller, finer strokes and for filling in small areas – perfect for our little 15-minute projects!

PAINT PALETTE

I tend to go for a porcelain palette with lots of flat mixing space, but any palette will work well. When I first started using gouache, I used an old tea saucer!

GLASS JAR FILLED WITH WATER

Use this to water down your gouache and rinse your paintbrush. Try to swap out the water a few times while painting, which will stop any murky paint from the water jar muddying your work.

PAPER TOWELS

Super helpful for drying your brush and preventing excess water dripping onto your work.

Other materials you might want to try if you choose to take your art journey further:

PENCILS

It's usually good to have a range of pencils to use for sketching, shading and toning, as well as drawing lines and tracing. I use a small set of Winsor & Newton pencils, ranging from a 2H to an 8B.

ERASER

PENCIL SHARPENER

PAPERS AND SKETCHBOOKS

Stillman & Birn are my go-to choice. I started my painting journey using their tiny, pocket-sized sketchbooks, which I love. I also really enjoy using Etchr's hot press sketchbook. For loose paper, I love Strathmore mixed media paper and Claire Fontaine multimedia gummed paper pads.

Don't feel that you need to get bogged down with expensive papers when you're starting out, but to prevent warping or bleeding though the page, it's best to use slightly thicker paper. I would suggest experimenting with different textures and weights of paper to see what you prefer painting on. I personally lean more towards a smooth surface, but I know many artists who love beautifully textured watercolour paper.

Using Gouache

SWATCHING YOUR COLOURS

When trying your paints for the first time, spend a few minutes swatching all the colours to become familiar with them. Try diluting them with more or less water, to see how this changes the opacity.

Keep these swatches nearby – they can be really useful when it comes to mixing new shades. It's also a good idea to test your colours over a darker shade too, to see how the paint behaves when you are layering dark to light. I do this by painting a black line across my page and layering my colour swatches over and along the line. We won't be going into too much colour theory here but getting to know the colour wheel and how your paint behaves goes a long way when you are mixing your own shades.

CONSISTENCY

Gouache can be diluted with water to make thinner or thicker washes. For the majority of the projects in this book, we'll be using thicker washes, but it's good to experiment with thinner washes as you may find you prefer these.

What is the correct amount of water to add? Just enough to create a smooth, buttery texture which stays opaque, but one that is thin enough so it doesn't crack once dry. The amount of water added often depends on the brand of paint – for example, I find HIMI Jelly gouache tends to be very thick and requires more diluting, while tubes of gouache need less. Some tubes of paint occasionally differ between the colours. This is something you'll get used to as you become familiar with your chosen brand.

How wet should the paintbrush be? Damp but not wet. After washing your brush, dab it into your paper towel to remove excess water. There's nothing worse than being part way through a painting and a huge droplet of water falling from the ferrule (the metal band between the handle and the bristles), smudging all of your hard work!

PAINTING DARK TO LIGHT

I tend to start with the darker values and work my way up to the lighter values, which is the way I've set the steps out in this book. Some people prefer to work the opposite way, but working on top of shadows feels more cohesive and I love keeping the final details until last – they're usually the most fun!

LAYERING GOUACHE

As we discussed earlier, gouache is perfect for layering. Leaving time for your layers to dry, however, is very important. Painting wet gouache onto wet gouache can sometimes cause your painting to look 'muddy', so we're sticking to painting dry on dry here.

Colour
Story

Before you begin mixing your colours, it's a good idea to familiarise yourself with the colour wheel. The typical artist's colour wheel shows the relationship between primary, secondary and tertiary colours.

PRIMARY COLOURS are colours that cannot be created from any other colours. They are red, blue and yellow.

SECONDARY COLOURS are the colours you get when you mix variations of the primary colours together. They are purple, orange and green.

TERTIARY COLOURS are created by mixing primary colours with secondary colours. These become your red-orange, yellow-orange, yellow-green, blue-green, blue-violet and red-violet colours.

Each of these colours is often referred to as a hue. Add black to that hue and it becomes a shade. Add white and it becomes a tint and add both black and white (grey) and it becomes a tone. The value of a colour relates to the lightness or darkness of the hue – for example, how much white or black paint is added to it. All of the values of the primary, secondary and tertiary colours can be altered by adding black or white, enabling you to create a whole host of incredible colours.

This is also a good opportunity to talk briefly about colour schemes. We won't be focusing on colour schemes in this book, mainly because we'll be replicating those found in nature, but you can use the colour wheel as a starting point if you choose to take your painting skills further.

COMPLEMENTARY COLOURS

These are the colours found opposite each other on the colour wheel. For example, red and green, purple and yellow, or blue and orange. Complementary colours are highly pigmented and appear to clash but are usually paired together to create drama.

SPLIT COMPLEMENTARY COLOURS

This is a variation of the complementary colour scheme. In addition to the base colour, it uses the two colours adjacent to its complement. This scheme is usually bold and vibrant but creates less tension than complementary colours.

ANALOGOUS COLOUR SCHEME

Three colours next to each other on the colour wheel. One of the most harmonious of colour schemes, analogous colours can often be found in nature.

MONOCHROMATIC COLOUR SCHEME

Tints, shades and tones of the same hue. We'll see a lot of this type of scheme in our leaf projects.

TRIADIC COLOUR SCHEME

Three colours that are evenly spaced on the colour wheel, such as purple, orange and green.

Sketching

For those who may not be totally confident about sketching, I've included templates for every project in the back of the book. Simply grab a sheet of tracing paper, lay it over the template and sketch over the top. When tracing I use a very soft pencil on the underside, meaning you end up with a stronger traced line to follow.

Position the tracing paper where you want to transfer the drawing to transfer in your sketchbook. The side of the tracing paper you drew on should be facing down. Rub the back of the traced drawing to transfer it onto the paper. You can either use your pencil, the end of a marker or another hard object for this.

If you want to try freehand drawing, then this sketchbook is a great place to practice! You don't even have to follow my exact designs; if you've seen an interesting leaf, blossom or flower on your travels, feel free to use your own reference images to recreate them.

The first tip when it comes to sketching is to start by studying your reference photo carefully, letting your pencil lightly translate the shape and details onto your paper. I find it helps to spend more time looking at the reference than your sketch. Often if you spend more time staring at your paper, you could find yourself starting to draw what you think your image should look like, rather than how it actually looks. The aim here should be to really familiarise yourself with your reference image (the shape of it, where the light hits it, the textures and details) before you put paint to paper.

My initial sketches are usually comprised of light, short pencil strokes, using a hard HB, or a 2H pencil which allows for more precision. I then overlap my pencil lines until the sketch starts to look the way I want it to. Don't worry about your sketches being messy and remember that pencil lines can always be erased, painted over and neatened up once your painting is finished.

At this stage I don't add any shading as I'll be painting over all the pencil lines. In some cases, though, I will loosely block out dark or light areas to help guide me when it comes to layering.

Project 01

Begonia Leaf

There are few plants whose leaves outshine the flowers, but the *Begonia* is one of them. With their beautiful, elongated oval shape and intricate spots, the leaves are a joy to paint, and a subject I return to again and again.

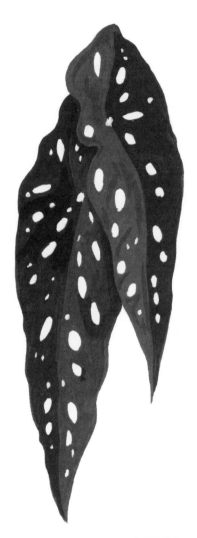

STEP 01

Trace the template on page 224. Take a size 6 paintbrush and, using a mix of olive green and a small amount of black, block out the areas of shadow. For more impact, blend a slightly darker tone of green along the inside edge of the leaf on the left, where the two leaves start to overlap, as well as into the creases of the leaves where you'll be adding the veins in step 3. Don't forget to leave negative space for the begonia spots – you'll be filling these in later!

STEP 02

Block in the lighter areas of the leaves next using a blend of sap green and olive green, which should be three to four shades lighter than the shadows.

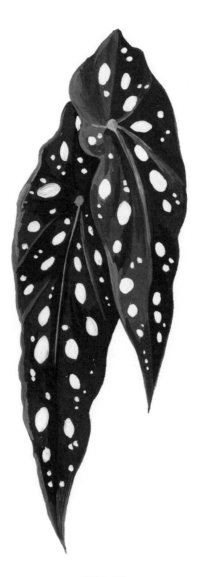

STEP 03

Using a size 3 brush, blend a light sage green (olive green mixed with a little white) into the areas where the light hits the top leaf and the tip of the bottom leaf. Using a lime green, add detail along the edges of the leaves and highlight the leaf veins through the middle. Using a light cream (white with a very small amount of olive), fill in the begonia spots. Feel free to get creative and add smaller dots of cream among them.

Project 02

Forget-me-nots

Forget-me-nots always amaze me – they may be small, but they are so striking!

If you have longer than 15 minutes, why not try dotting a few more together on your page to create a beautiful, repetitive pattern?

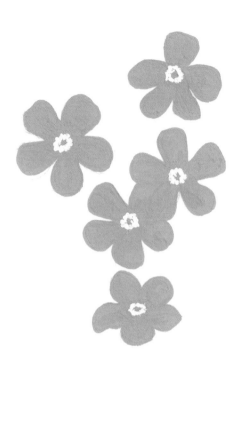

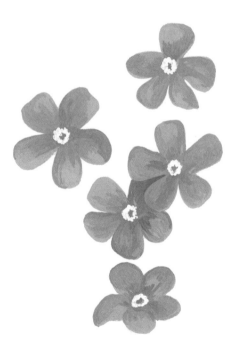

STEP 01

Trace the template on page 225. Using a size 3 paintbrush, mix some primary blue paint with a little white and block out the flower petals. Changing to a size 1 brush, add a few small dots of white paint to the centre of each flower. Allow to dry.

STEP 02

With the size 3 brush, mix a little ultramarine blue into the primary blue and blend some shadows into the centre of the flower petals, dragging and blending the shade out toward the edge of the petals.

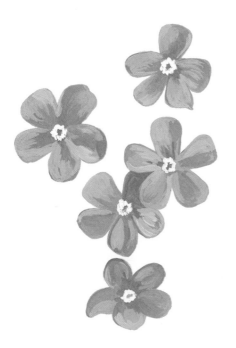

STEP 03

With a size 1 brush, mix a lighter version of the primary blue using more white paint, and add some highlights around the edges of the petals. Remember, the blending doesn't have to be perfect. Sometimes it's really nice to see some of those brushstrokes.

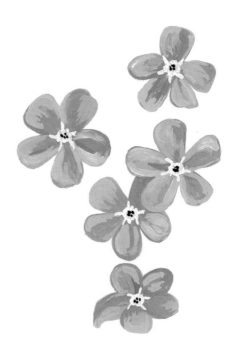

STEP 04

Using a size 1 brush, take a light yellow and block in the centre of your forget-me-nots. Add fine strokes of white from the base of the stamens in the centre of the flower to separate each petal. Finally, add a few tiny dots of ivory black to the middle of each flower.

Project 03

Chinese Money Plant

This is one of my all-time favourite houseplants not only because of its little pancake-like leaves and long delicate stems, but also its history. The Chinese money plant was brought to the UK in 1906 by botanist George Forrest and earned the nickname 'pass it on plant', as it was so easy to propagate that cuttings spread widely across the country. I'm sure it's not the case, but I love to think that all our Chinese money plants here in the UK originated from this one single plant over 100 years ago.

STEP 01

Trace the template on page 225. Using a size 5 or 6 paintbrush, fill in the leaves of the plant using sap green, leaving a little negative space in the areas indicated. We'll be filling these in later.

STEP 02

Add a little black to the sap green to create the shadow tones. Using the same size 5 or 6 brush from step 1, lightly paint the darker gouache along the outsides of the leaves, blending into the centre of each one.

STEP 03

Take a smaller brush (between a 1 and 3) and paint this same shade along the stems of each leaf. Rinse your brush and allow the paint to dry for a few minutes. In the meantime, take some Vandyke brown and, using the same brush, fill in the main stem. Add a little white to the brown, and lightly paint a few strokes on the stem to indicate where the sunlight would hit it.

STEP 04

Lastly, mix together sap green and a little white, and, using your size 1 to 3 paintbrush, blend a few highlights on the outside of a few of the leaves. Use this same shade to fill in the little negative spaces you left in step 1. While these are drying, add a little primary yellow to the sap green and white mix, and blend this into the highlights of the most prominent leaves (the ones you'd like to draw your viewer's eye to).

Project 04

Bracken Fern

I absolutely LOVE painting ferns. They are super simple, but the finished result is incredibly striking. We'll be working on a couple of different types of fern in this book, as there are so many beautiful varieties I couldn't possibly just choose one! Here, we'll be painting a very simplified close-up of some bracken, which, as I write this, is starting to unfurl along the pathways of my local woodland.

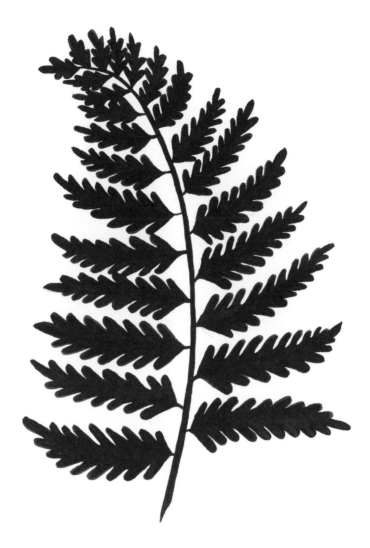

STEP 01

Trace the template on page 224. Mix some olive green with
a little water and, using a size 3 paintbrush, fill in the leaves
and the delicate stem running through the centre of the fern.

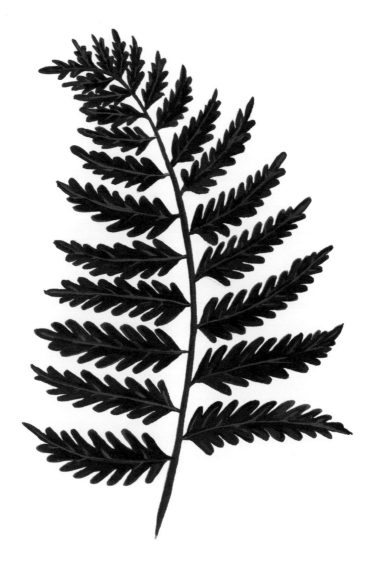

STEP 02

Mix a little white into the olive green, and using the tip of a size 1 brush,
lightly paint the veins through the middle of the leaves. As this dries, mix
some olive green with a little black, add a few shadows along the veins of
the leaves and blend lightly outwards. Remember no leaf is identical, so
these don't have to be perfect!

Project 05

Wildflowers

Nothing says summer to me like a field full of beautiful wildflowers and I've always wanted to pay homage to them. You can either paint a single wildflower – which would make a beautiful little postcard – or a few grouped together if you want something more impactful. The great thing about this piece is that it's so stylised, it really doesn't have to look like a realistic wildflower. Just pick your favourite colours and have fun!

STEP 01

Trace the template on page 225. Using a size 1 paintbrush and some sap green, light green, sage green and lime green, start painting the stems and leaves of your wildflowers.

STEP 02

Rinse your paintbrush and use sky blue, mauve, peach, deep yellow and white to paint the petals. These don't have to be completely even, but to help with scale, it can be helpful to build your petals in a circular motion, to keep them roughly the same size.

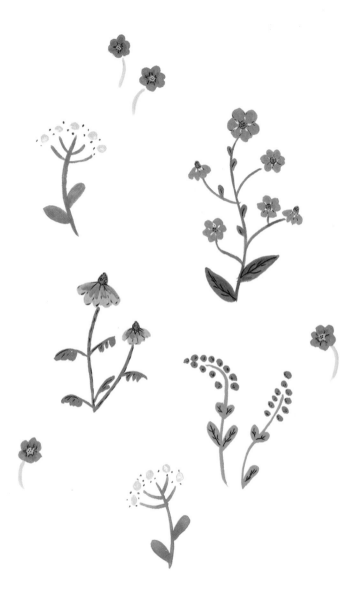

STEP 03

Take a slightly darker shade of blue (you can also add a little red or black to the sky blue) and add some shadow to the blue flowers. Do the same with your pink and yellow flowers, using slightly darker shades of pink and yellow. Using yellow and orange, fill in the middle of your flowers, then wait until the paint is completely dry before using a black fineliner pen to add little lines and dots of detail.

Project 06

Mimosa

How glorious is a huge bunch of bright yellow mimosa? I've never had the fortune of seeing it growing in the wild, but absolutely love it in a big cheerful vase, and it's a real joy to paint.

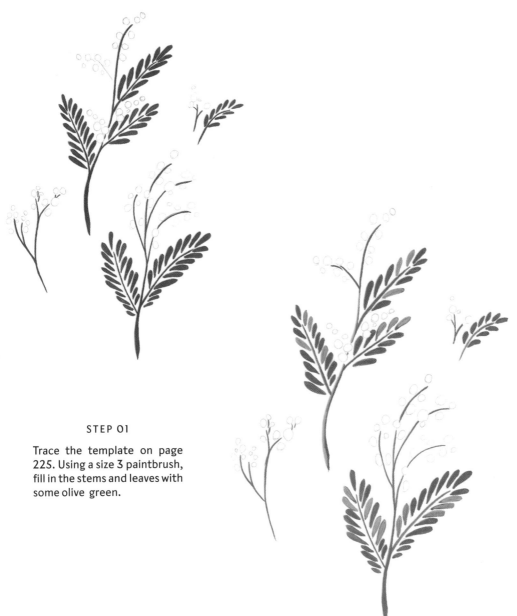

STEP 01

Trace the template on page 225. Using a size 3 paintbrush, fill in the stems and leaves with some olive green.

STEP 02

Add a little yellow to the olive green to create a warm, light green. Once the stems and leaves from step 1 are dry, go in with the same brush and highlight a few leaves at random.

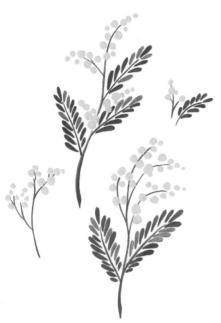

STEP 03

Rinse your brush and fill in the
little round flowers with some
primary yellow.

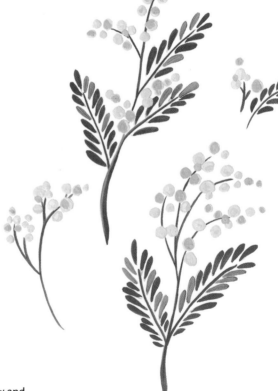

STEP 04

Mix a little white into the primary yellow and
dab this onto the flowers to create some
highlights. Finally, use a deep yellow to paint
into a few flowers for added depth.

Project 07

Muscari

Muscari (or grape hyacinth), always makes my heart sing when it starts to bloom in spring. I planted my own muscari bulbs for our little tiny patio garden for the first time this year and they were a real joy in an otherwise very gloomy lockdown.

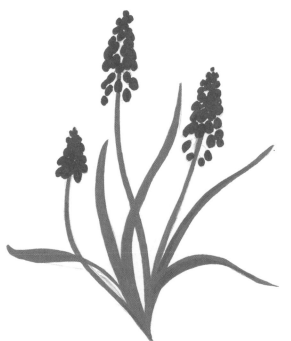

STEP 01

Trace the template on page 224. Using a size 3 to 5 paintbrush, fill in the leaves and stems with an olive green and the petals with a primary blue.

STEP 02

Add a little black to the primary blue and fill in the shadows around the inner edge of the petals. Mix a little black with some olive green and add shadow along the right side of the stems, then blend into the leaves.

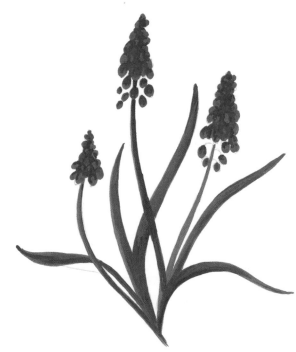

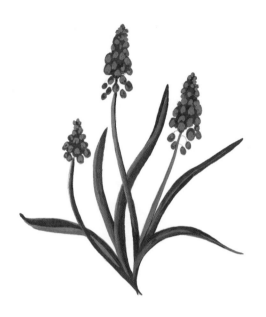

STEP 03

Using a mix of primary blue
and white, add little dabs
of paint to the petals to
create some highlights.
Mix some olive green and
a little white and paint long
strokes along the outer
edges of the leaves and
stems.

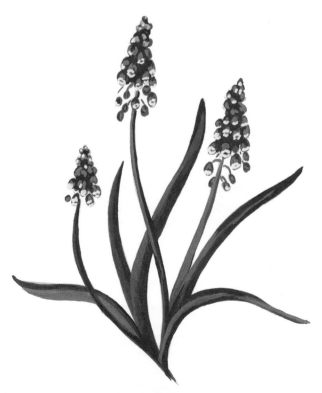

STEP 04

Add more white to the
blue and white mix from
step 3. Taking a size 1 brush
and using the very tip,
delicately paint in the frills
of the muscari petals.

Project 08

Variegated Leaves

When I find myself a little stuck for inspiration or unable to head outside and explore, my houseplants really come into their own. Here we're going to learn how to paint variegated leaves. While I was teaching myself to paint, I found these a little overwhelming. No leaf is the same and paintings really do go through that 'ugly stage' all artists dread. Push through that, though, and the end result is truly lovely!

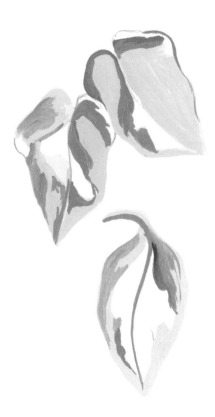

STEP 01

Trace the template on page 226. We're going to be working light to dark here, so start with a size 3 to 5 paintbrush and mix together olive green, a little primary blue and lots of white to block out the sections of the leaves.

STEP 02

Add more olive green to the mix and start working brushstrokes into the edges of the sections already painted.

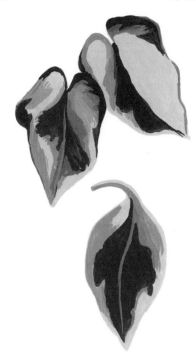

STEP 03

Keep adding more olive green and primary blue to the same mix, working messier brushstrokes into the light areas you painted in step 1. You are trying to create the appearance of irregular patterns. Rinse your brush and use olive green mixed with a little black to fill in the darker areas.

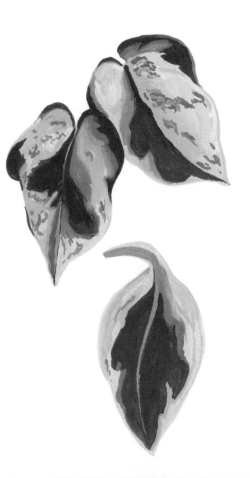

STEP 04

Finally, take some olive green and a size 1 paintbrush and add little dots to the lighter areas.

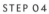

Project 09

Echinacea

How beautiful are these flowers? I can't help but be drawn to them when they're in full bloom in the summer. Echinaceas are such a joy to paint as there are so many different colours and shapes to choose from.

We're going to go with a peachy, two-toned variety here, although you can switch these colours for any complementary shades you like.

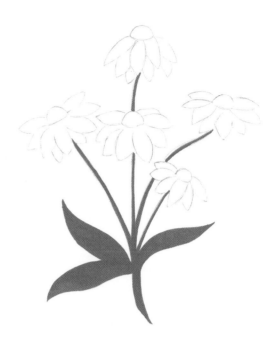

STEP 01

Trace the template on page 226. Block in the leaves and stems with sap green, using a size 3 paintbrush.

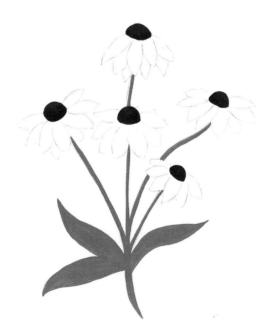

STEP 02

Using Vandyke brown, block in the centre of the flowers. To add dimension, add a little more water to the paint as you work your way up, which will result in a lovely gradient of colour.

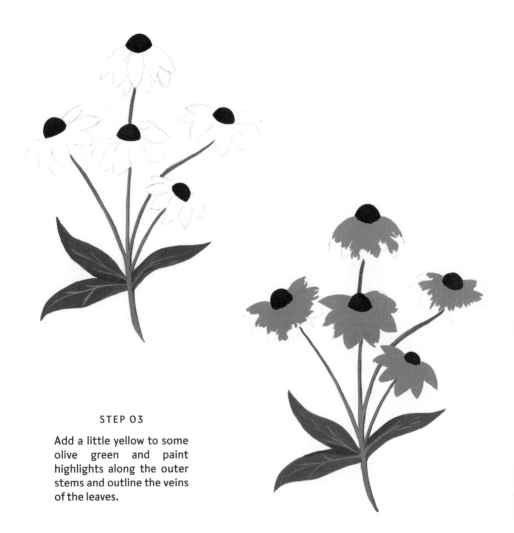

STEP 03

Add a little yellow to some olive green and paint highlights along the outer stems and outline the veins of the leaves.

STEP 04

Mix a little primary red into some white and layer the pink colour onto sections of the petals, as shown.

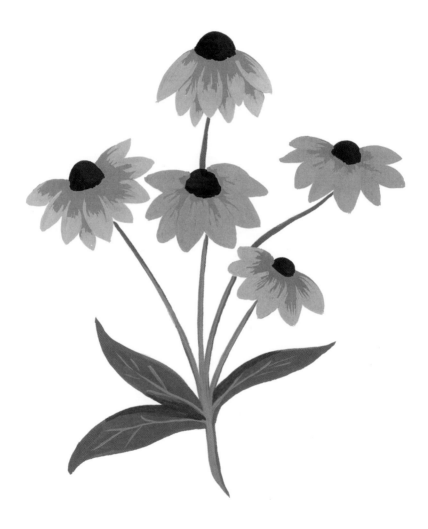

STEP 05

Add a little more white to the pink mix and paint the edges of the middle and
right flowers. Feather the brushstrokes to prevent the colours looking blocky.
Mix together peach and a little orange and repeat for the remaining flowers.

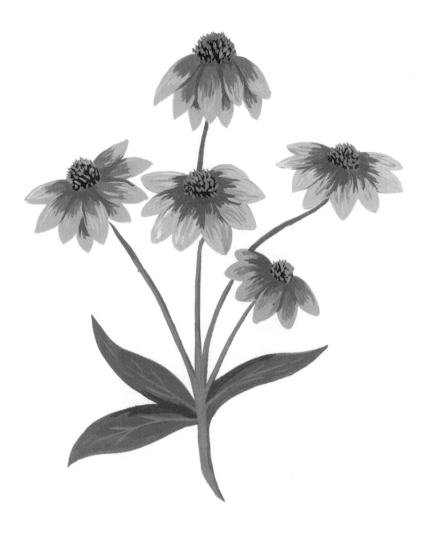

STEP 06

Work both primary red and orange between the petals. Finally, add a few little
white brushstrokes to the petals. Lightly dab the remaining orange paint into
the centre of the flowers.

Project 10

Foxgloves

As a child I used to take the name of this wildflower very literally and loved imagining foxes trotting through the garden wearing these delicate flowers as little socks. Adorable! Like echinaceas, foxgloves come in so many colours, so feel free to be as creative as you like with your palette.

STEP 01

Trace the template on page 227. Take a size 3 paintbrush and block the leaves and stems of your foxglove with olive green.

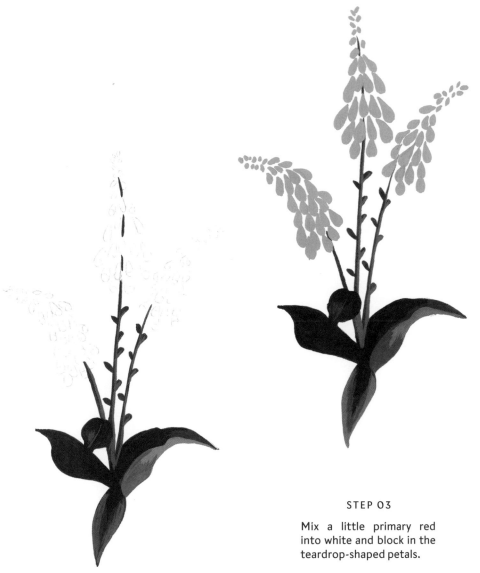

STEP 03

Mix a little primary red into white and block in the teardrop-shaped petals.

STEP 02

Mix olive green with a little black and blend into the inside of the leaves to mimic shadows. Add a little white to the olive green and paint one side of the stems and the outside of the leaves to make the highlights.

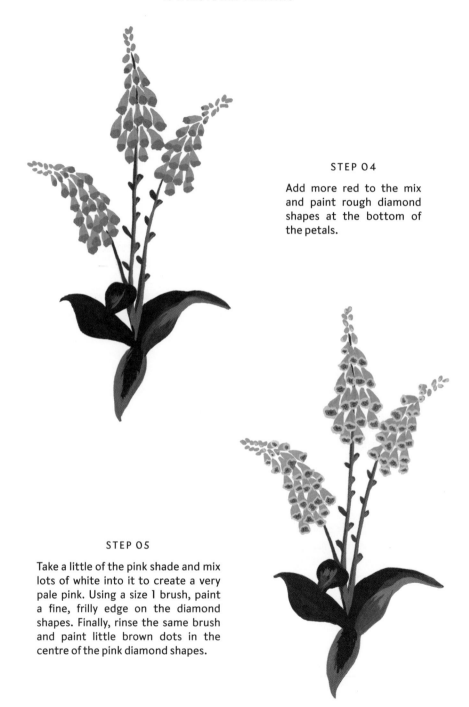

STEP 04

Add more red to the mix and paint rough diamond shapes at the bottom of the petals.

STEP 05

Take a little of the pink shade and mix lots of white into it to create a very pale pink. Using a size 1 brush, paint a fine, frilly edge on the diamond shapes. Finally, rinse the same brush and paint little brown dots in the centre of the pink diamond shapes.

Project 11

Fritillaria

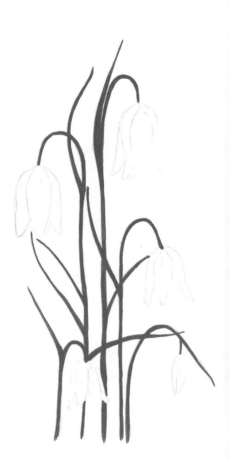

One of my favourite flowers, fritillarias are so delicate that watching them bob their heads in the spring breeze is an absolute joy. I've painted them here outside their habitat, but they would also look beautiful in a meadow of long, sweeping grass.

STEP 01

Trace the template on page 227. Using sap green and a size 3 paintbrush, fill in the delicate stems.

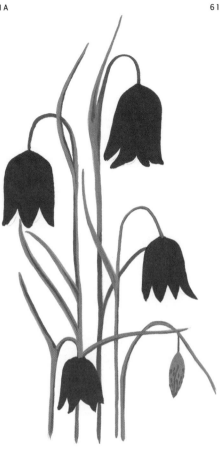

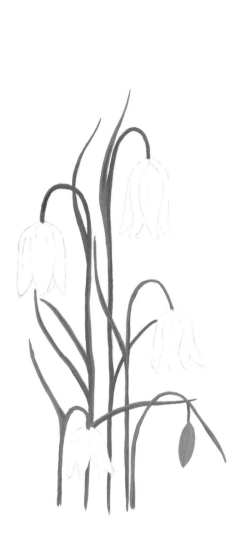

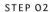

STEP 03

Mix ultramarine blue, primary red and a little white to make a purple, and fill in the flower heads. Using the same purple, add a few small dots to the flower bud.

STEP 02

Add a little white to the sap green to create the highlights on the stems and block in the flower bud on the right.

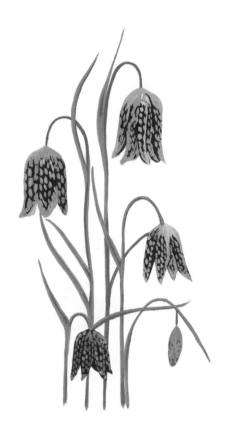

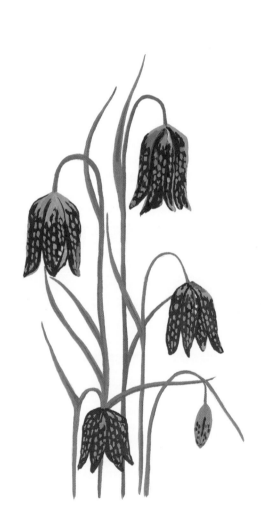

STEP 04

Add more white to the purple shade and dab the colour down the petals to create a checkerboard pattern. Blend the same colour into the top of the flowers and along the bottom of the petals.

STEP 05

Mix a darker shade of purple by following step 3 but this time add more blue to the blend. Fill the gaps in the checkerboard pattern and outline the shape of each petal. Add little dark purple dots to the flower bud.

Project 12

Willow Leaf

There's something so romantic about weeping willows. As beautiful as they are to look at, they can be quite tricky to paint, so here I've focused on a bunch of their wispy, elegant leaves.

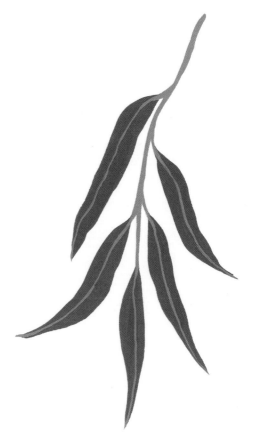

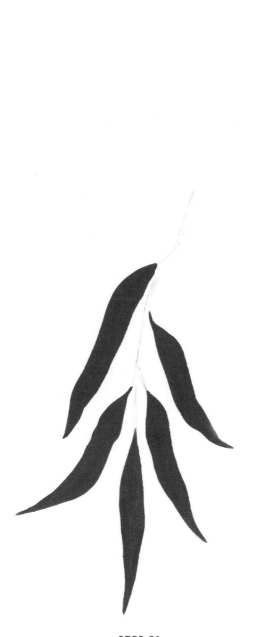

STEP 02

Add a little white to the olive green and fill in the branch, sweeping the brush down the centre of each leaf and tapering off very slightly at the tip.

STEP 01

Trace the template on page 226. Using a size 3 paintbrush and olive green, block in the leaves.

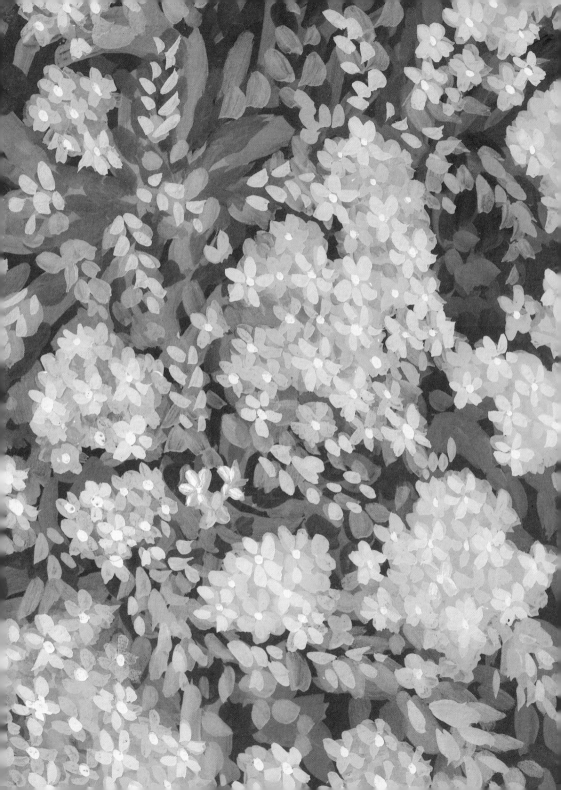

Project 13

Prickly Pear Cactus

I love spending time at botanical gardens and I'm always drawn to the cacti. There are so many different shapes, colours and textures. For this project we'll be painting a prickly pear. I love their organic shapes, and the little pink flowers give such an eye-catching pop of colour.

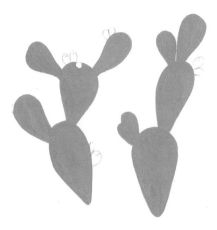

STEP 01

Trace the template on page 226. Using a size 5 or 6 paintbrush, fill in the oval leaves using light green.

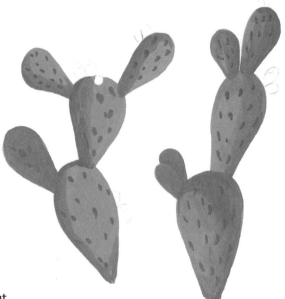

STEP 02

Add a little black to the green paint mix and brush shadows into the edges of the leaves, blending towards the centre. Using a size 3 brush, paint cactus spikes on the leaves in the same shade.

STEP 03

Mix together primary red and a little
white and fill in the cactus flowers.
Add more white to the pink mix and
dot highlights onto the top of the
flowers, as shown.

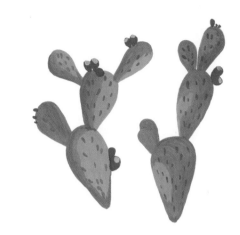

STEP 04

Mix a little light green into
some white and overlay
more cactus spikes onto
the leaves at random.

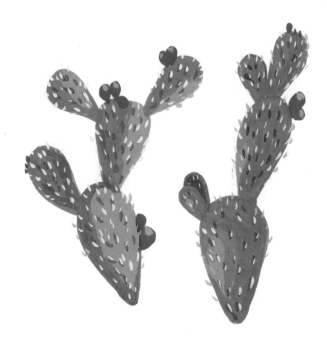

Project 14

Fairy Tale Toadstool

There's a little area of our local forest that is covered in pine trees and, at certain times of the year, these little fairy tale toadstools can be spotted growing underneath them. Highly toxic, painting them is probably much safer than picking them ...

STEP 01

Trace the template on page 227. Using a size 3 to 6 paintbrush, mix together white and a little yellow ochre to block in the base of the stalk. Add a little more yellow ochre and a tiny dab of Vandyke brown and block in the skirt of the mushroom. Rinse your brush and block in the mushroom cap using spectrum red.

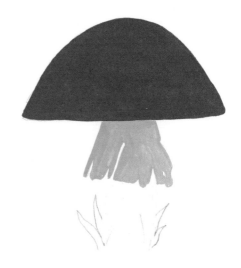

STEP 02

Mix more brown into the yellow ochre mix and blend this colour into the skirt of the mushroom, leaving a little negative space on the right where the light would hit. Mix together Vandyke brown and a little black and, using a size 1 to 3 brush, add stronger shadows to the area where the skirt and the stalk meet. You could also add a few brushstrokes to the stalk to imitate a rippled texture. Add a small amount of black to the red and blend this into the mushroom cap, ensuring it's darker on the left-hand side and blends out towards the right.

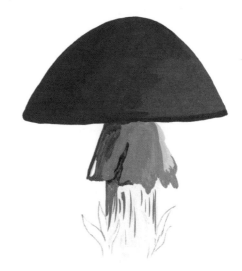

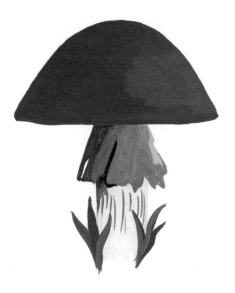

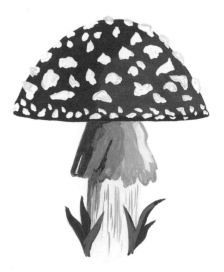

STEP 03

Using sap green and a size 1 brush, fill in the grasses at the base of your mushroom.

STEP 04

Take a size 3 brush and start painting white spots in a random pattern on the mushroom cap. These spots aren't perfectly round, so have fun creating different sizes and shapes!

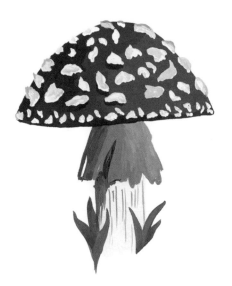

STEP 05

Add a little dab of black to the white paint and brush a small shadow into some of the spots. Taking the same colour you used for the red shadows, paint a few shadows underneath some of the spots at random. Note that I have added these mostly to the left of my mushroom cap, where the shadow is falling.

Project 15

Scalloped Shell

Some of the best inspiration can be found at the beach. Next time you are beachcombing, try photographing a collection of different shells, then use the incredible colours, markings and shapes as inspiration.

STEP 01

Trace the template on page 228. Mix a Vandyke brown, red and white to create a warm, light brown. Using a size 3 paintbrush roughly paint the stripes along the scallops of the shell.

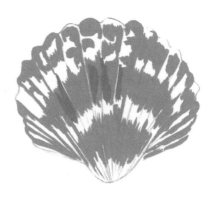

STEP 02

Mix a little Vandyke brown with some white and fill in the blank stripes between the brown layers created in step 1. Don't be afraid to drag the lighter colour over the darker brown to really overlap the two layers.

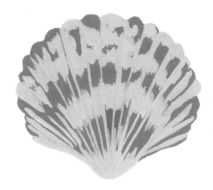

STEP 03

Use the Vandyke brown to outline some of the edges of the shell ridges to differentiate them from the horizontal scalloped ridges.

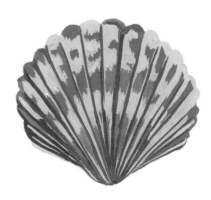

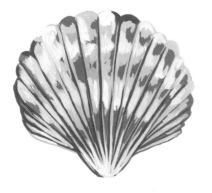

STEP 04

Warm up the white with a very small amount of Vandyke brown and use this to loosely brush in the highlights.

STEP 05

Lastly, take the warm brown you mixed in step 1 and paint it back into the shell to neaten up any edges.

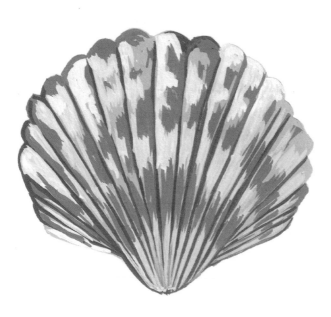

Project 16

Grasses with Wildflowers

If you've ever found yourself painting a landscape, you'll know that something which really helps make the foreground pop are layers of frothy grasses. Combine these with contrasting wildflowers and you have a beautiful whimsical scene.

STEP 01

Trace the template on page 228. Using a size 1 to 3 paintbrush, water down some olive green paint. The trick to painting wavy grasses is to start from the base and use loose, quick strokes and a flick of the wrist to taper each blade of grass to a point at the end. Group these grasses into small clumps and don't be afraid to layer them. Leave to dry.

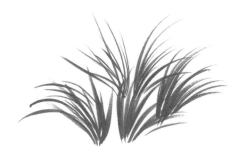

STEP 02

Add a little white to the olive green and repeat the technique described in step 1 to work the lighter shade among the darker tones.

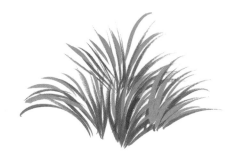

STEP 03

Mix together primary yellow and a little white. Then, using the tip of your brush, dab the colour among the grasses to paint the wildflowers.

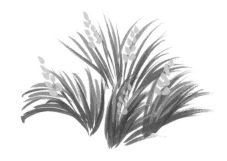

Project 17

Monstera Leaves

There's a reason why *Monstera* (Swiss cheese plant) leaves are having such a moment right now – they are so much fun to paint! With their huge, glossy green leaves, they're a great project to try if you only have a few minutes to spare.

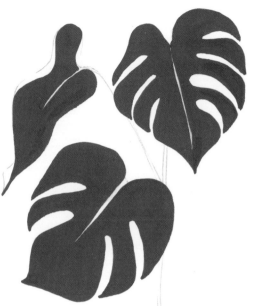

STEP 01

Trace the template on page 228. Use a size 5 paintbrush and olive green paint to block in the leaves. Allow to dry.

STEP 02

Take the same olive green and mix in a little black to create a deep, rich green. Using the same brush, blend this shade into the leaves to form the shadows. If you want a lighter coloured leaf, add fewer shadows at this stage.

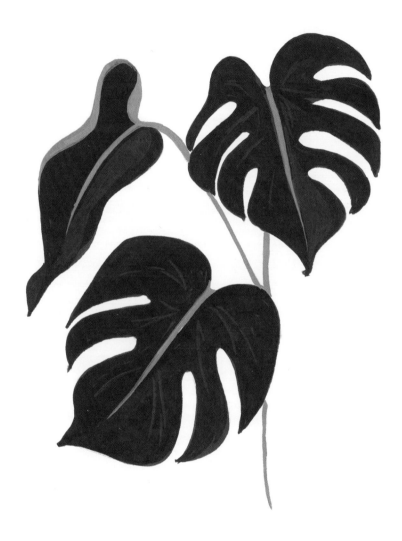

STEP 03

Mix together olive green and a little primary yellow and, using a size 3 brush, block in the stems, the central veins and the rounded edges of the top-left leaf. Taking the olive green from step 1, lightly add veins to the two flat leaves.

Project 18

Eucalyptus

If you're looking for a quick and simple project to start with, this is it! There's a reason why eucalyptus is used to adorn beautiful wedding invites and luxury stationery. Its leaves are both delicate and striking - try using more diluted washes of paint if you'd like to create the look of a watercolour.

STEP 01

Trace the template on page 229. Mix some willow green with a little white and, using a size 1 to 3 paintbrush, block in the leaves. Rinse your brush and mix Vandyke brown with a little white to block in the main stem and branches.

STEP 02

Using olive green, add some new leaves and fill in a few of the existing leaves with this darker shade too.

STEP 03

Add more white to the willow green mix from step
1 and add veins to the leaves. Use the darker olive
green to add veining to a few of leaves, too.

Project 19

Woodland Foliage

Inspired by woodland foliage, I've created this project to give you a little insight into painting dappled light on shadowed leaves.

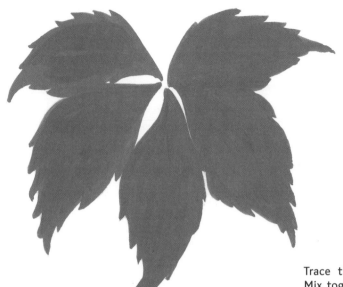

STEP 01

Trace the template on page 229. Mix together sap green and a little black. Using a size 3 to 6 paintbrush, block in the leaves.

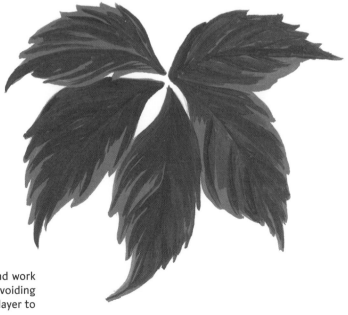

STEP 02

Add more black to the mix and work shadows into the leaves, avoiding some areas to allow the base layer to show through.

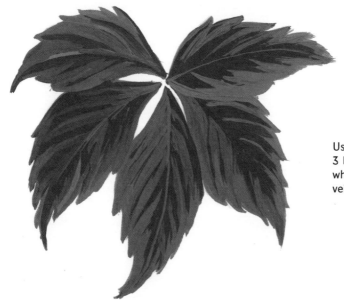

STEP 03

Using sap green and a size 3 brush, paint in the areas where you imagine the leaf veins would sit.

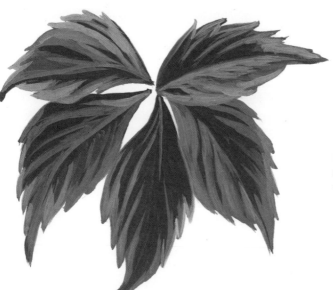

STEP 04

Using lime green, add some highlights around the edges of the leaves.

Project 20

Snowdrop

Snowdrops are one of my favourite flowers to paint. They also happen to be my birth flowers, so I just had to include one here for you to try. Using white paint on paper can be a little tricky, as can working shadows into white paint, but I'll show you a really simple yet effective way to do this.

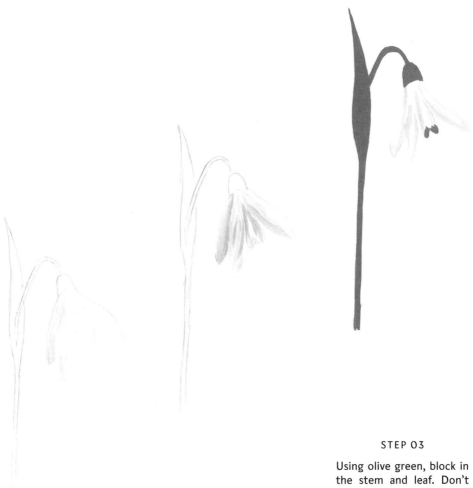

STEP 03

Using olive green, block in the stem and leaf. Don't forget to add the same colour to the tips of the petals in the centre of the flower.

STEP 02

Add a little more black to the white mix to create a soft, pale grey. Work this tone into the inner edges of the petals, focusing on the centre of the flower.

STEP 01

Trace the template on page 228. Mix a tiny dot of black into some white paint. Using a size 3 paintbrush, block in the flower head and petals.

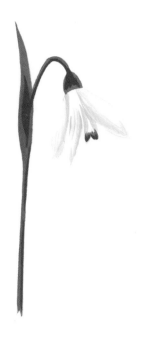

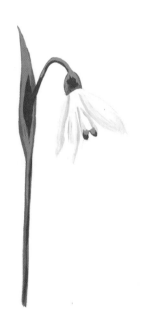

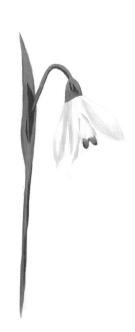

STEP 04

Mix a little black into the olive green and blend shadows into the stem and leaf.

STEP 05

Mix together olive green and a little white and blend some highlights into the stem, leaf and centre of the flower (over the olive green you added to the petal tips in step 3).

STEP 06

Finally, work a little sap green along the outer edge of the stem and into the tips of the central petals and green base of the flower for added contrast.

Project 21

Thistle

This project is one that looks super impressive and complex once finished but is actually pretty easy to create!

STEP 01

Trace the template on page 229. Mix willow green with a little white and block in the stems and leaves.

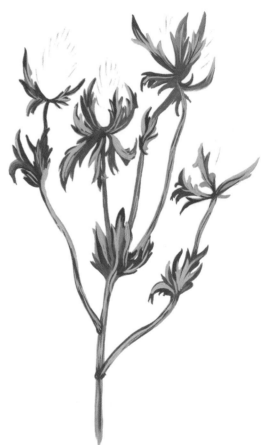

STEP 02

Use some willow green to work shadows into the stems and leaves, leaving negative space for the base layer to show through.

STEP 03

Add more white to the willow green mix and work some highlights into the shadows.

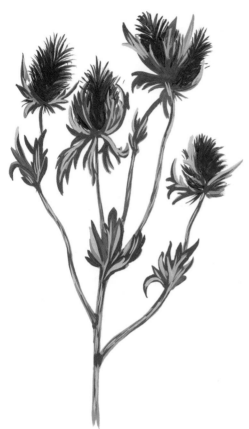

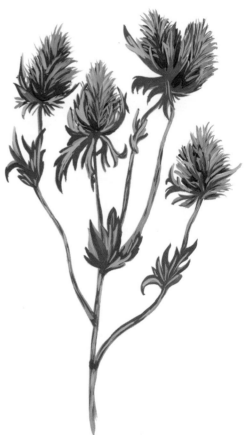

STEP 04

Using primary blue mixed with a little black, fill in the areas where the thistle flowers would sit, flicking the paintbrush up and out to create thin spikes.

STEP 05

Mix together primary blue and a little white and work spikes of light blue into the flower heads of the thistles.

Project 22

Cow Parsley

A familiar sight here in the UK, I always know that summer has arrived once the cow parsley starts to bloom in the hedgerows. Frothy and delicate, this plant is beautiful painted either alone or as a picturesque posy of wildflowers.

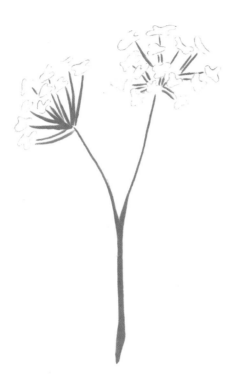

STEP 01

Trace the template on page 230. Using sap green and a size 1 to 3 paintbrush, fill in the delicate stems.

STEP 02

Mix a little black into the sap green and work shadows into the stems. Rinse your brush and add the frothy flower heads using white paint.

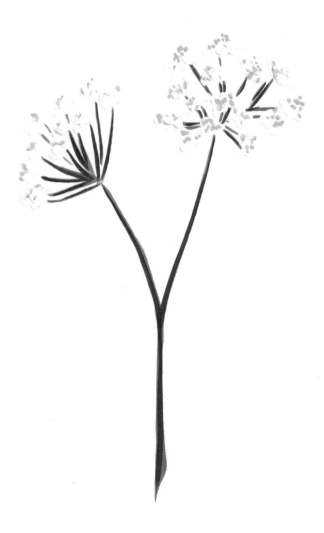

STEP 03

Add white to the sap green and, using the tip of the brush,
dab little dots of detail into the flower heads.

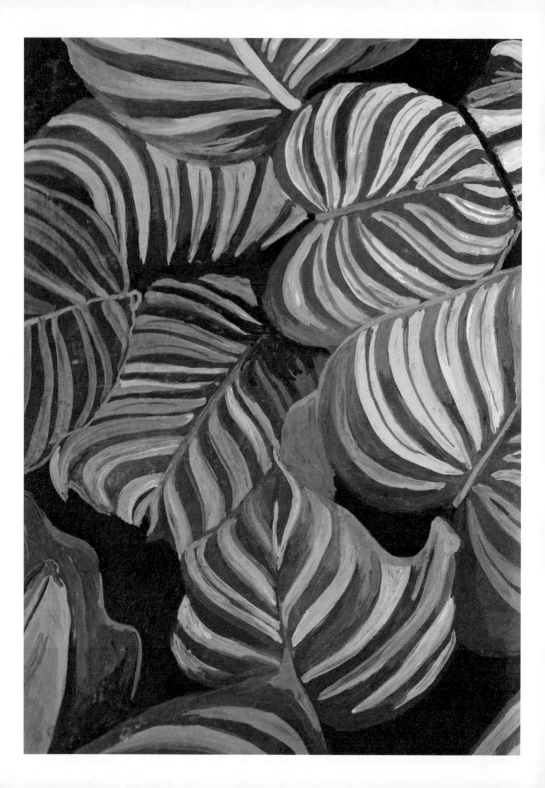

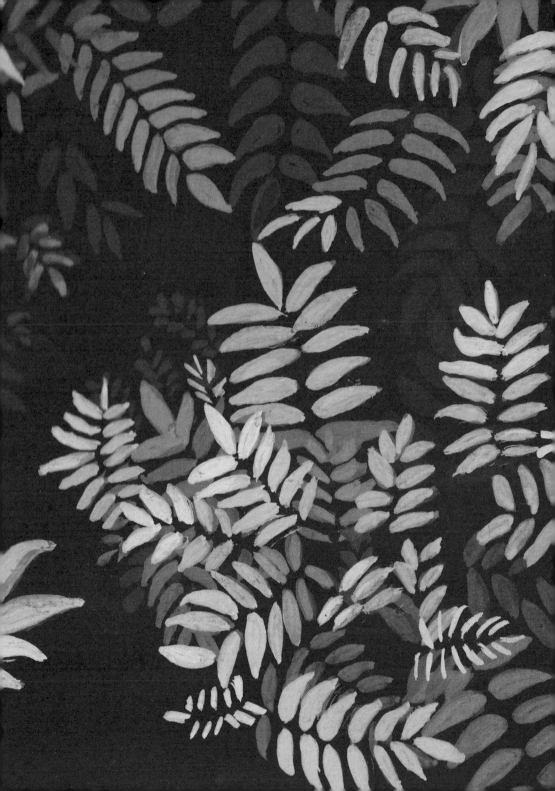

Project 23

Syngonium Leaves

I'm a big fan of the bright, arrow-shaped leaves of *Syngonium*, one of my favourite houseplants. These plants are so low maintenance that they still look incredible even if I accidentally forget about them for a few days - oops! No *Syngonium* leaf is the same, but each has such beautiful markings, I knew I had to include this plant in the book.

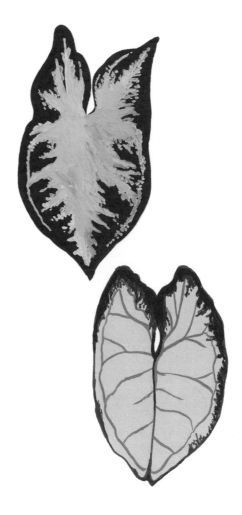

STEP 01

Trace the template on page 231. Mix together olive green and a little black to make a deep shadowy green and use a size 6 paintbrush to block in the top leaf. Mix together sap green, primary yellow and a little white to block in the bottom leaf. Allow to dry for a few minutes.

STEP 02

Start creating the leaves' veins. Use lime green to fill in the centre of the top leaf. Then, with the tip of the paintbrush, extend the veins to the edges. Using the tip of your brush helps to avoid harsh lines and creates dab-like brushstrokes. Using the deep shadowy green from step 1, repeat the same brushstroke technique around the edge of the bottom leaf, concentrating on the top and right-hand side. Water down the shade a little and add the veins. Using a relaxed hand gives the veins a natural look.

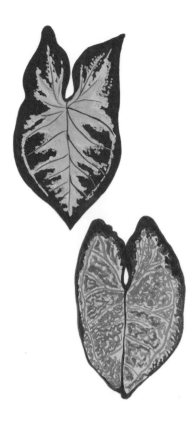

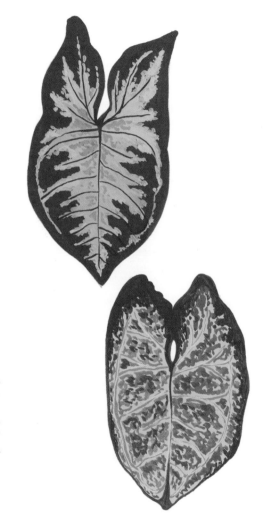

STEP 03

Using the same deep shadowy green from steps
1 and 2, repeat the brushstroke technique from
step 2 to add darker veins to the top leaf. Then
use sap green and olive green to add texture to
the bottom leaf. Start with the sap green and
work olive green over the top. Don't be precious
about your lines here.

STEP 04

Mix olive green with a little white and add some
detail along the centre of the top leaf. Mix in a
little more white and highlight the veins of the
bottom leaf.

Project 24

Sea Urchin

So much inspiration can be found by taking a stroll along the beach. I live inland, so a trip to the seaside provides me with endless inspiration. Smooth, glossy pebbles, textured seaweed and frothy waves are just some of nature's bounty that is waiting to be discovered. Occasionally, you may also come across a few sea urchins along the shore. Their beautiful organic shapes and textures make them the perfect subject to paint.

STEP 01

Trace the template on page 230. Using a size 1 to 3 paintbrush, fill in the stripes, alternating between a light and warm brown. To give the sea urchin its shape, be sure to keep the lines rounded and taper them from narrow to wide.

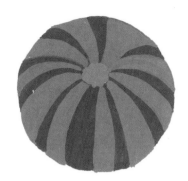

STEP 02

Create an off-white using white and a very small amount of brown. Using the tip of your brush, dab various-sized dots of this colour along the stripes.

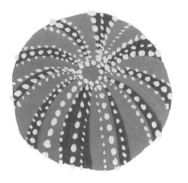

STEP 03

Make a light grey by mixing white with a little black. Using the same technique described in step 2, dab this shade into some of the white dots and inside the ring of dots at the top of the sea urchin to create added interest.

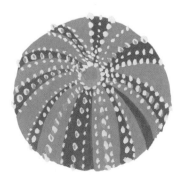

Project 25

Forest Mushrooms

Autumn is one of my favourite seasons. Everything appears to be bathed in beautiful soft sunlight, the trees begin to turn gold and different types of mushrooms and fungi start to take over my local forest. I usually head out with my camera to snap pictures of the mushrooms and fungi (remembering not to touch them!) for inspiration later. If you can't find any growing near you, you could also paint the interesting edible wild mushrooms you sometimes find at the supermarket.

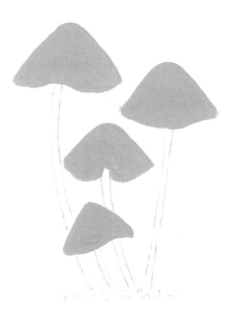

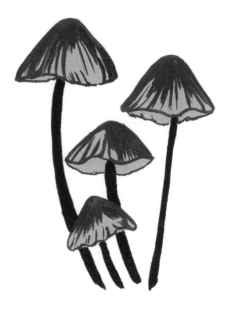

STEP 01

Trace the template on page 230. Mix white with a small amount of Vandyke brown and, using a size 1 to 3 paintbrush, fill in the mushroom caps.

STEP 02

Take the Vandyke brown and size 1 brush and, starting at the top of the mushroom cap, drag the brush downwards to create the frills of the mushroom cap. Add a little black to the Vandyke brown and fill in the stems.

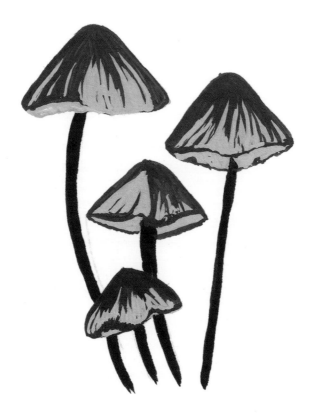

STEP 03

Mix white with a little Vandyke brown
and a small amount of black to create
a light, warm grey. Use this to add a
few brushstrokes to the mushroom
caps for extra detailing.

Project 26

Grasses with Wheat

Different types of grasses often feature in the foreground of my mini sketchbook spreads. They're so much fun to paint and bring an added interest to landscape paintings. Most of my grasses follow the same design, but I add various elements, depending on the scenery.

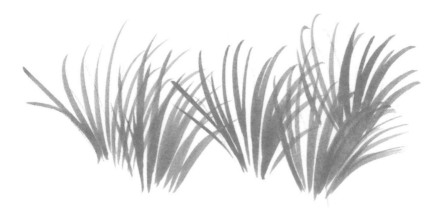

STEP 01

Trace the template on page 231. Dilute some sap green so it's a little less opaque than usual – this helps when painting quick, loose lines. Using a size 1 paintbrush and this shade, hover your brush where the base of the blade of grass will start and in one quick, swift motion, flick the brush upwards. I tend to bunch my blades of grass together to make them look more natural. This may take a little practice, but as soon as you've mastered it you'll be able to paint fields of grass in no time!

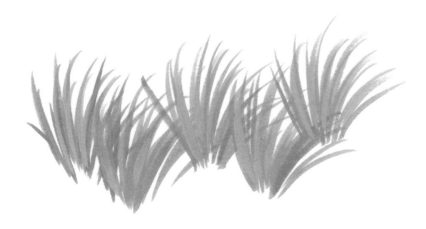

STEP 02

Mix a little white into the sap green and repeat step 1 to add more depth to your patches of grass.

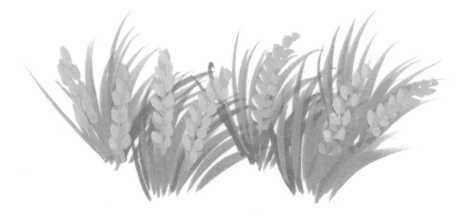

STEP 03

Add more white to the paint mix and
create the ears of wheat by pressing
the tip of your paintbrush onto the
paper. Nestle these into the grasses
for a wild, natural look.

Project 27

Wispy Grasses

Another type of grass I paint often is something I refer to as wispy grass. These grasses usually appear quite large in the foreground of my work, and their soft, frothy seedheads give landscapes a soft, ethereal look.

STEP 01

Trace the template on page 231. Using a size 3 paintbrush, block out the background using olive green. Rinse your brush, and while the olive green is still wet, layer lime green above it, blending in the edges. If you find the two colours difficult to blend, rinse your brush again and lightly dry it so the bristles are damp. Work your brush into the paint to gently blend the colours together.

STEP 02

Add a little white to the olive green and, using a size 1 brush, paint the blades of grass at random, but in the same direction, over the background. This will give your grass a beautiful windswept feel.

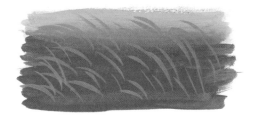

STEP 03

Mix olive green with a little Vandyke brown and repeat step 2, filling in some of the negative space.

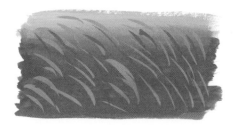

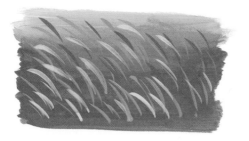

STEP 04

Repeat step 3 using lime green. Feel free to overlap and layer some of the blades of grass.

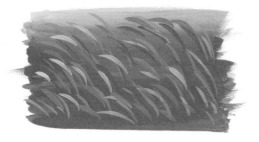

STEP 05

Using a diluted sap green, repeat step 4.

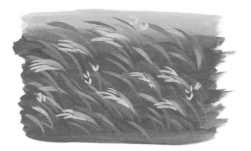

STEP 06

Using a diluted white and swift, short strokes, add a frothy texture to create the seedheads of the grasses. Add as many or as few of these as you like, and stagger them across the field.

Project 28

Grasses with Bulrushes

One way to create a really dramatic landscape is to add tall, delicate grasses to the foreground. This gives the viewer the perspective of being sat in the painting, looking over the view.

STEP 01

Trace the template on page 231. Using a size 1 paintbrush, dilute some olive green and stagger the first layer of grasses across the foreground.

STEP 02

Mix yellow ochre with a little white and repeat step 1, filling in some of that negative space. Using the same colour, sweep your brush upwards in a curving arc to create the tall stems of the bulrushes. Rinse your brush and mix Vandyke brown and a little primary red, and use this shade to paint the bulrush seedheads.

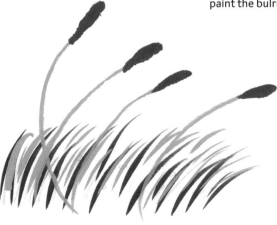

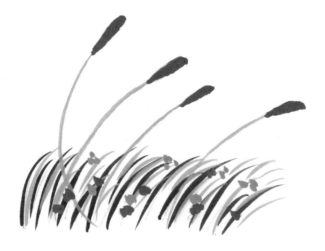

STEP 03

Mix yellow ochre and a little primary
red and use this to dab small flowers in
among the grasses for added interest.

Project 29

Dandelion Grasses

Dandelion grasses follow the same base layers as the previous three grasses projects but have different details. Free free to add your own style here by mixing up the colours. Or get creative by adding some clover, bluebells or patches of daisies.

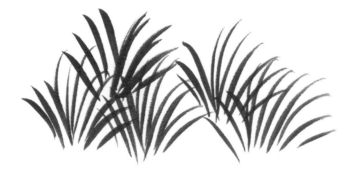

STEP 01

Trace the template on page 231. Dilute some olive green so it's a little less opaque than usual and, using a size 1 paintbrush, hover it over where the base of your blade of grass will start. Then, in one quick, swift motion, flick the brush upwards. I tend to bunch my blades of grass together to make them look more natural.

STEP 02

Mix a little white into the olive green and repeat step 1 to add more depth to the patches of grass.

STEP 03

Adding more white to the olive green and using the tip of
your paintbrush, dab imperfect circles among the grasses
to create your choice of flowers.

Project 30

Pine Tree

I found trees pretty daunting
to paint at first; there's so much
depth and intricacy, yet they're
so incredibly majestic. No tree
is the same, and I love watching
them move through the seasons.
Although a painting can't truly
do them justice, I find them so
much fun to paint and one of my
favourites to study are pine trees.

STEP 01

Trace the template on page 230. Using a size 3 paintbrush fill in the trunk using Vandyke brown. While the paint is still wet, run brushstrokes of white through the trunk to imitate the texture of bark.

STEP 02

Mix sap green and black to create a deep, forest green. Using a size 3 to 6 brush, focus some shadows in the centre of the pine tree, dragging them along its branches. Note where I have left negative space where the tree branches part.

STEP 03

Roughly work some sap green over the shadows created in step 2, dragging the colours further along the branches. Don't cover up all the shadows, – you want some of these layers to remain visible.

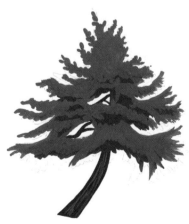

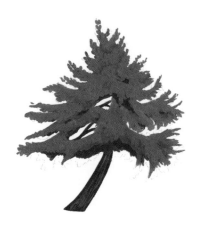

STEP 04

Mix together olive green and a little white and work this shade over the sap green, using the tip of your brush to create leaves along the branches.

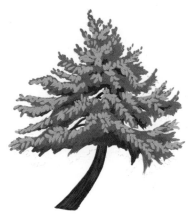

STEP 05

Add a little primary blue and more white to the olive green, painting more leaves over the olive-green highlights created in step 4.

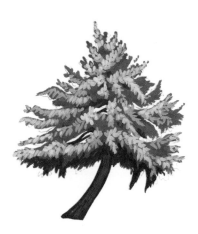

STEP 06

Finally, mix primary yellow, olive green and a little white, and use this to paint in the lightest leaves.

Project 31

Buttercups

Come late spring, the fields and hedgerows here in the UK are strewn with bright, summery buttercups. They bring back memories of childhood nursery rhymes and warm summer afternoons. They're so cheerful, I knew I had to include a little bunch of them here.

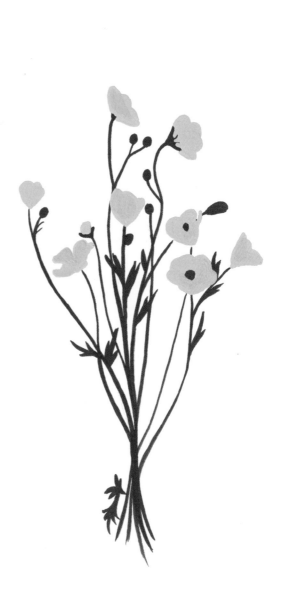

STEP 01

Trace the template on page 233. Using olive green and a size 1 paintbrush, paint the buttercups' stems and small leaves.

STEP 02

Fill in the petals using a deep yellow.

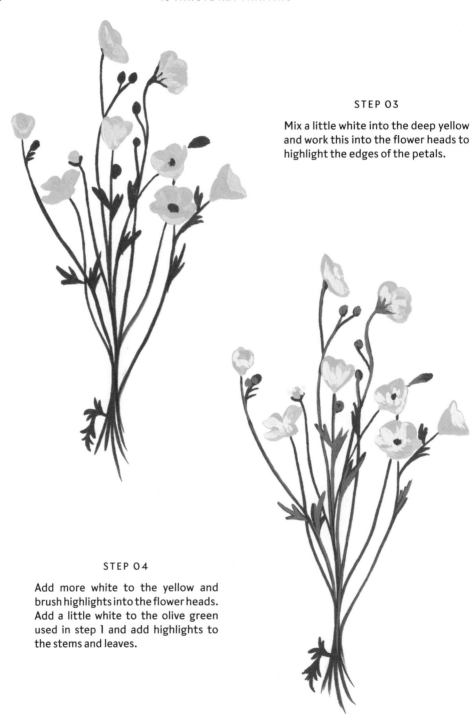

STEP 03

Mix a little white into the deep yellow and work this into the flower heads to highlight the edges of the petals.

STEP 04

Add more white to the yellow and brush highlights into the flower heads. Add a little white to the olive green used in step 1 and add highlights to the stems and leaves.

Project 32

Conch Shell

Another beach find that is a joy to paint is the conch shell and with so many different colours and markings, no shell is the same!

STEP 01

Trace the template on page 233. Mix yellow ochre with a little white and fill in the outlines of the shell using a size 1 paintbrush.

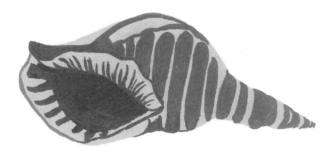

STEP 02

Fill in the ridges of the shell and paint in the spine using yellow ochre mixed with a little Vandyke brown. Mix a little primary red into the yellow ochre to create a warm orange and fill in the inside of the shell.

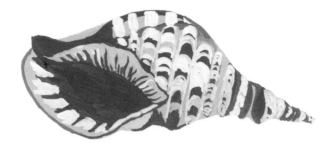

STEP 03

Add more white to the yellow ochre
and white mix from step 1 and start
creating the stripes across the ridges.

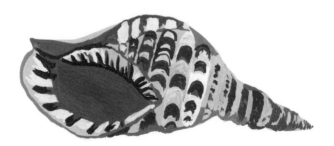

STEP 04

Mix Vandyke brown and a little black
and outline the columella fold (the
central, structural axis) and some
areas along the ridges.

Project 33

Maidenhair Fern

Another reason why I love painting ferns is that they're so versatile. There are so many different species but I've focused on two of my favourites in this book: bracken ferns (see page 30) and maidenhair ferns.

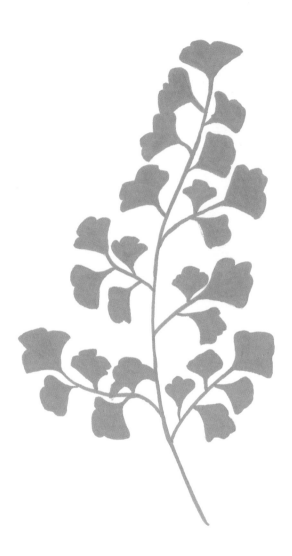

STEP 01

Trace the template on page 232. Mix a light green and sap green to create a bright, vibrant shade. Using a size 1 paintbrush, fill in the fern's stems and leaves.

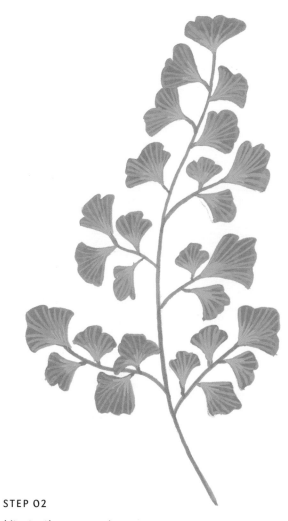

STEP 02

Add a little white to the green mix
and, starting from the leaf stem, paint
the veins of the leaves. Add a little
more white to the mix and brush a fan
of shorter veins from the bottom of
each leaf.

Project 34

Daffodil

Daffodils are one of those flowers that make my heart sing. When I start to wonder if winter will ever end, they begin to bloom, reminding me of the longer, sunnier days to come. We'll be painting a detailed daffodil, but you can also create smaller studies as part of a beautiful spring landscape.

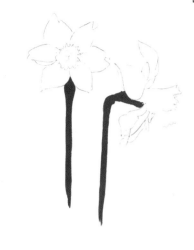

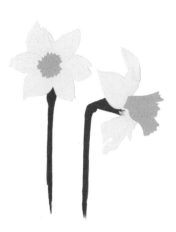

STEP 01

Trace the template on page 233. Fill in the stems using olive green and a size 1 to 3 paintbrush.

STEP 02

Fill in the petals and coronas (the daffodil's trumpet) using primary yellow and orange.

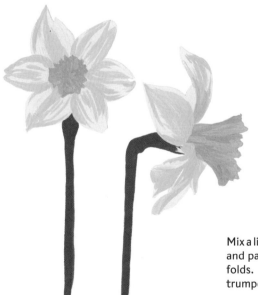

STEP 03

Mix a little yellow and orange together and paint in the shadows of the petal folds. Repeat this process for the trumpet of each daffodil.

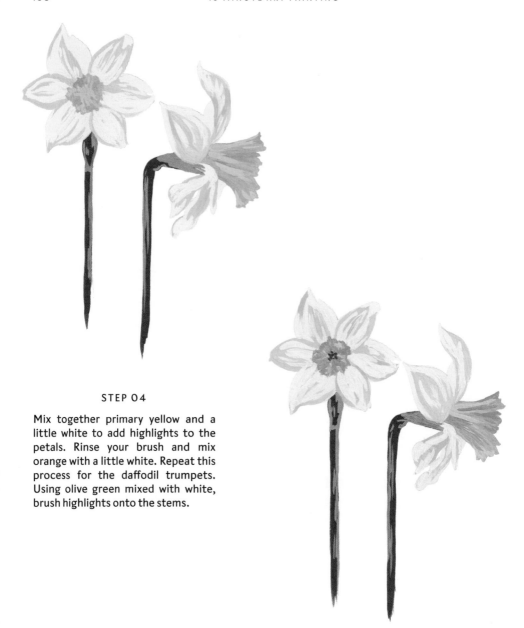

STEP 04

Mix together primary yellow and a little white to add highlights to the petals. Rinse your brush and mix orange with a little white. Repeat this process for the daffodil trumpets. Using olive green mixed with white, brush highlights onto the stems.

STEP 05

Using primary red and the tip of your paintbrush, dot the anthers in the centre of the daffodil on the left.

Project 35

Elephant Ear Leaf

Also known as *Colocasia esculenta* or taro, you'll probably recognise these incredible plants by their distinctive large, heart-shaped leaves. They are thought to have originated in Southeast Asia and their glossy leaves make a great painting subject.

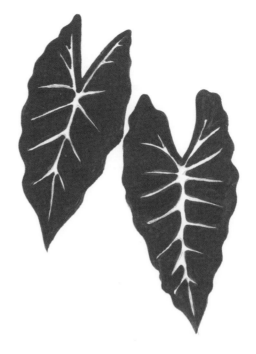

STEP 01

Trace the template on page 233. Mix olive green with a little black and fill in the leaves using a size 1 paintbrush. Don't forget to leave some negative space for the leaf veins.

STEP 02

Mix olive green with a little white and add highlights to the leaf edges.

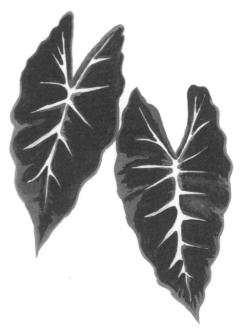

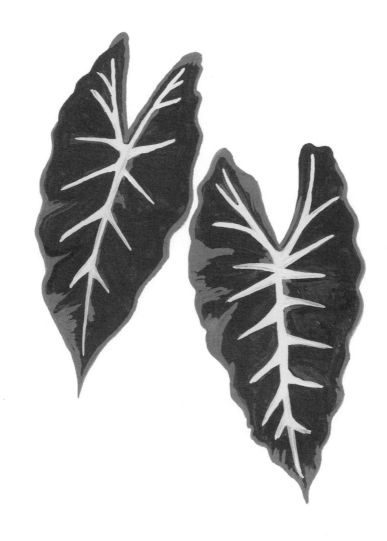

STEP 03

Add more white to the paint mix from
step 2 and fill in the leaf veins.

Project
36

Golden
Barrel Cactus

When I'm stuck for inspiration, I love to take a weekend to wander around my favourite botanical gardens. With such a wide variety of plants, you can easily head home with an entire camera roll full of beautiful reference images. Or if you have more time, nestle inside the cactus house and try sketching some of the cacti while you're there.

STEP 01

Trace the template on page 232. Using a size 3 paintbrush, fill in the cactus using some willow green. Block in the soil with Vandyke brown and paint the pot using Vandyke brown mixed with a little black and white.

STEP 02

Mix a little black into the willow green and add shadows to your cactus. Blend the shadows into the base layer with a clean, damp brush. Using Vandyke brown and a size 1 brush, paint in the shadows under the ridges of the pot.

STEP 03

Add highlights to your cactus using willow green mixed with a little white. Then mix a little Vandyke brown into white to paint highlights on the plant pot and soil.

STEP 04

Add spines to the cactus using the same shades you used for the pot shadows and highlights. Try alternating the spines in different shades of light and dark. Lastly, taking a light brown, add small patterns to the plant pot.

Project 37

Nasturtiums

Like a lot of people during the pandemic, I found myself enjoying getting out into my tiny patio garden, which reignited my love of gardening. So much so, a friend and I have now taken on our own allotment! The first thing we'll be growing this year will be nasturtiums. With their bright jewel colours and beautiful marble patterns, they're not just wonderful to look at, but they're easy to care for, too.

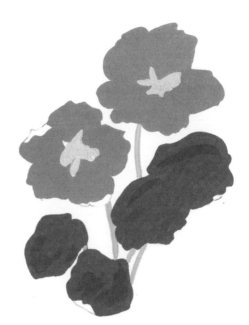

STEP 01

Trace the template on page 232. Using a size 1 paintbrush fill in the petals with a peach colour. Leave negative space for the curled petals – we'll paint these later. Block in the centre of each flower using primary yellow, the stems with lime green and the leaves in willow green.

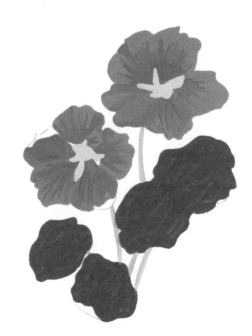

STEP 02

Mix a hot shade of pink using red and a little white. Work shadows into the petals using the same brush you used in step 1.

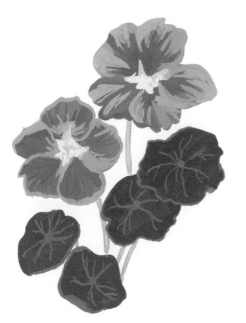

STEP 03

Add more white into the pink shade and paint highlights on the petals. Don't forget to fill in the petal folds now. Mix white with a little primary yellow and add highlights to the flower centres. Add white to the willow green and, using the tip of your brush, paint the veins of the leaves.

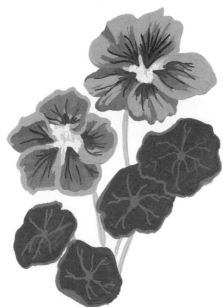

STEP 04

Add a little primary blue to the hot pink from step 2 and use the very tip of your brush to add more vein-like details to the petals. Work from the centre of the flower and drag your lines towards the edge of the petals.

Project 38

Crab Apple Blossom

Witnessing the different varieties of blossom bloom was a highlight for me during lockdown. Another source of natural beauty I had taken for granted before, the pandemic made me slow down and pay attention to the seasons. I learnt that the first blossoms to appear in my area are little delicate blackthorn flowers in spring, but my absolute favourite is the crab apple which starts to bloom in summer.

STEP 01

Trace the template on page 234. Using a size 3 paintbrush fill in the petals with a rose pink mixed with a little white.

STEP 02

Work shadows into the flower buds using rose pink. Add the same shade to the petals, using your brush to contour by following their curves.

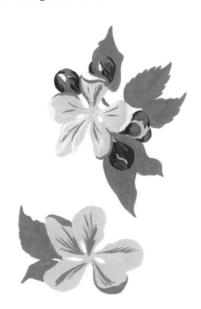

STEP 03

Add a little of the same rose pink to white to create a light, blush pink. Lightly work highlights into the petals, blending into the base layer.

STEP 04

Block in the leaves with sap green.

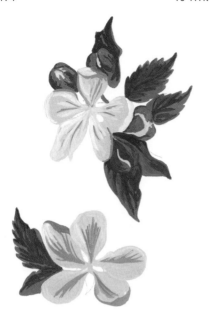

STEP 05

Add a little black to the sap green and
work some shadows into the leaves.

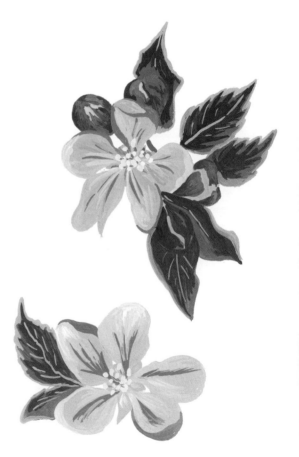

STEP 06

Mix sap green with a little white and work highlights into
the leaves' edges and veins. Use the same shade to paint
a few sepals between the petals. Then, blend more white
into the sap green mix and add dots for the anthers in the
centre of each flower.

Project 39

Cosmos

A great flower to start your foray into botanical painting is the cosmos as the large petals lend themselves well to beginners. English country gardens are full of cosmos in the summer, so if visiting gardens is something you enjoy, you're bound to come across a vast array of different varieties to use as inspiration.

STEP 01

Trace the template on page 234. Using a size 3 paintbrush fill in the petals with white mixed with a very small amount of black.

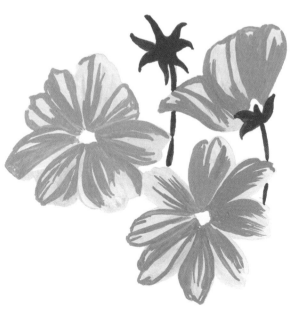

STEP 02

Fill in the stems and sepals using olive green. Create a shade of grey by adding a little more black to white paint and brush this into the petals to create the folds.

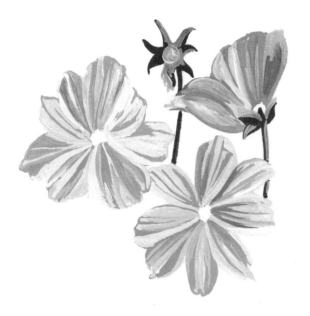

STEP 03

Using some lime green, add highlights to the stems and sepals. With a little white and using the tip of your brush, paint highlights into the petals.

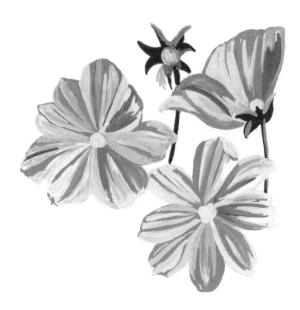

STEP 04

Using primary yellow, fill in the centre of the flowers.

Project 40

Saguaro Cactus

One of the defining plants of the Sonoran Desert, the saguaro cactus is recognisable due to its huge, column-like arms. The largest cactus in the United States, this plant often reaches over 40 feet tall!

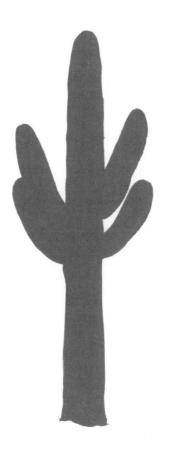

STEP 01

Trace the template on page 234. Fill in the cactus using some willow green. For an even, flat base, try using a size 5 to 6 paintbrush.

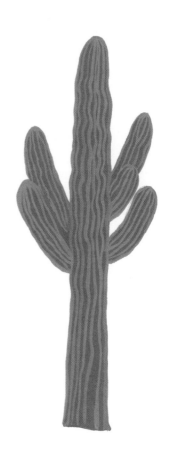

STEP 02

Mix a little white into the willow green and, using the tip of a size 1 brush, paint ridges into the cactus' stem and arms. These ridges aren't always straight, so try giving them gentle curves.

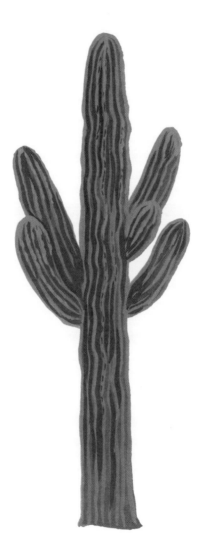

STEP 03

Mix together willow green and a little black. Using the tip of your size 1 brush, lightly paint shadows between the ridges.

Project 41

Violas

Sweet and cheerful, violas are a lot of fun to paint. The way their petals form makes them look as though they have little smiling faces! I took the references photos for these while exploring the grounds of an old country house. They had self-seeded in the cracks of some paving stones and looked so cute and delicate. We're sticking to the classic blue and white variety here, but they come in so many incredible shades that you could try mixing them up a little, if you wish!

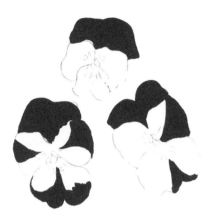

STEP 01

Trace the template on page 235. Using ultramarine blue mixed with a little black, fill in the outer petals using a size 3 paintbrush.

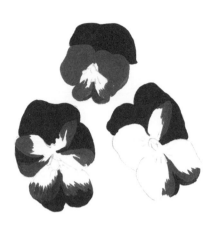

STEP 02

Add a little white to the ultramarine blue and repeat the process for the inner petals, leaving negative space for the mid-tones, as shown.

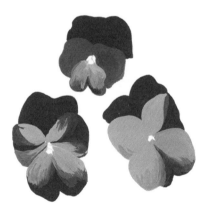

STEP 03

Add a little more white to the same shade you used in step 2 and fill in that negative space using a size 1 brush.

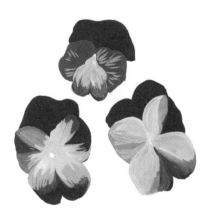

STEP 04

Add yet more white to the same shade and brush this lightly over the mid-tones from step 3, adding brushstroke detail to the petals of the top flower.

STEP 05

Using a deep yellow, add colour to the centre of the violas. Use a deeper yellow or orange to add further interest to the flower centres.

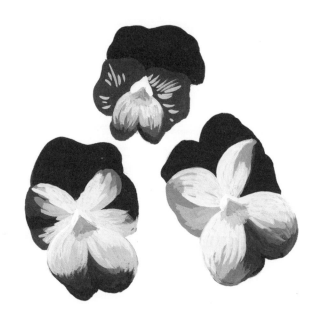

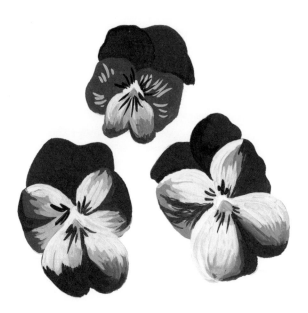

STEP 06

Add a little more black to the ultramarine blue and use the very tip of your brush to add quick brushstrokes around the centre of the flowers.

Project 42

Sweet Peas

For me, smell is one of the biggest memory triggers, and there's nothing like the scent of sweet peas to bring forth memories of heady summer afternoons. I love growing sweet peas over the doorway, so every time I step outside, I get a hit of that incredible perfume.

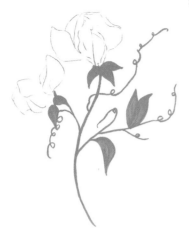

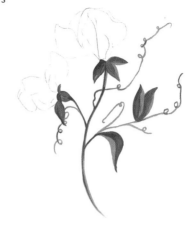

STEP 01

Trace the template on page 235. Mix sap green with a little white and fill in the leaves and stems with a size 1 paintbrush. Add the long, delicate tendrils, too!

STEP 02

Work shadows into the leaves using sap green mixed with a little black. Blend this shade through the main stem and side shoots, too.

STEP 03

For the warm pink, I mixed red with white and a little blue. Use this to block in the outer petals with a size 1 brush. Mix a little white into purple or lilac and use this for the inner petals. Don't forget to leave a little negative space, as shown.

STEP 04

Add a little white to the purple or lilac shade from step 3 and fill in the negative space. To make the painting look even more realistic, create an even lighter shade of purple or lilac and brush this through the centre of the inner petals, keeping the brushstrokes visible. Work highlights into the outer petals, too.

STEP 05

Add a little ultramarine blue to the lilac and, using the tip of your brush, add shadow outlines around the petal folds, working into the centre of the flowers.

STEP 06

Finally, take a little white, and while the paint is still a little damp, brush final highlights into the centre of each sweet pea flower.

Project 43

Poppy

With their big, saucer-like petals and striking shade of red, corn poppies are a joy to paint. I love painting them as close-up features or as a part of a wildflower meadow.

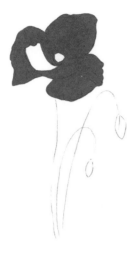

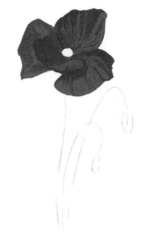

STEP 01

Trace the template on page 235. Block in the petals using red and a size 3 paintbrush.

STEP 02

Mix a little black into the red and, using a size 1 brush, sweep this into the petal creases to create shadows.

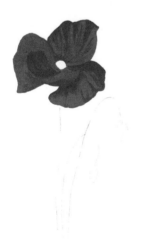

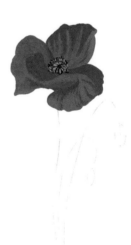

STEP 03

Mix together red, a little yellow and white to create a soft, peach shade. Work this over the top of the base layer, adding a little orange to create more depth.

STEP 04

Using deep yellow mixed with a little white, fill in the centre of the poppy. Allow to dry for a few minutes before adding black dot detailing to the centres.

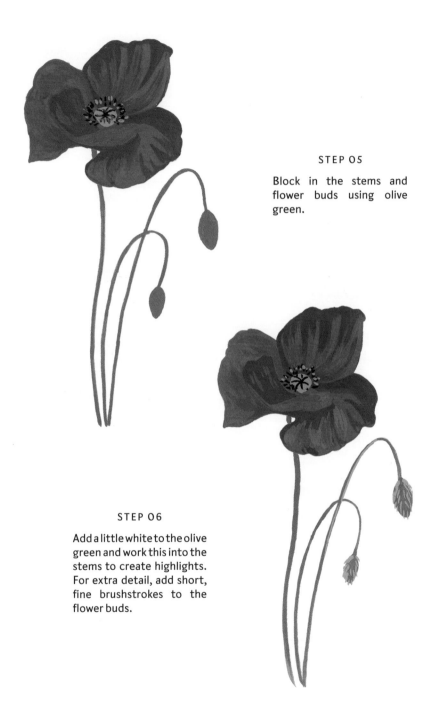

STEP 05

Block in the stems and flower buds using olive green.

STEP 06

Add a little white to the olive green and work this into the stems to create highlights. For extra detail, add short, fine brushstrokes to the flower buds.

Project 44

Calathea Leaf

Another striking houseplant that makes a great study is *Calathea*. With its wide, striped leaves this plant looks striking alone or as part of a group. The first time I tried painting this plant was in a little sketchbook and it's still one of my favourite paintings to date!

STEP 01

Trace the template on page 236. Block out the leaves using sap green and a size 3 to 6 paintbrush, leaving a little negative space through the middle of the leaves.

STEP 02

Mix sap green with a little white. Using a size 1 brush, paint the stripes on the leaves. To make the leaves appear more three-dimensional, keep the stripes slightly curved.

STEP 03

Add more white to the shade you used in step 2 and lightly outline two stripes on either side of the main stripes using the tip of your brush.

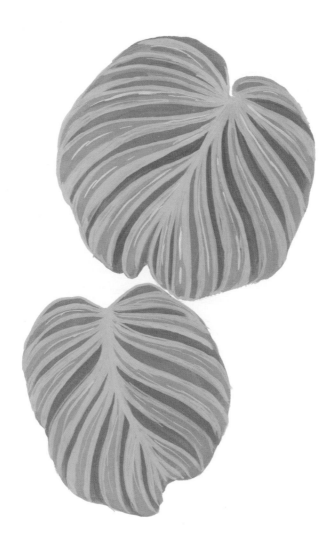

STEP 04

Using white, add short, light lines to a
few stripes to give the impression of
super-glossy leaves.

Project 45

Horse Chestnut Tree

Familiar to most of us as conker trees, horse chestnuts are reminiscent of childhood trips to the park to collect the best and shiniest conkers. As magnificent to paint as they are to look at, the appearance of horse chestnut trees differs dramatically depending on the season. If you feel like pushing your skills further, try painting the tree while it's in flower during spring, or even in its full autumnal glory, with orange and yellow leaves.

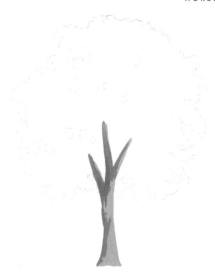

STEP 01

Trace the template on page 236. Mix white with a little Vandyke brown and using a size 1 to 3 paintbrush block in the tree trunk. To create a bark effect, mix a little black into the paint and roughly work this into the trunk and branches of the tree.

STEP 02

Mix together sap green and a little black and block out the tree leaves. Use a large brush here to speed up the process. I used a flat wash brush which gives a quick, even coverage. Allow this layer to dry for a few minutes.

STEP 03

Using a size 3 brush, work sap green over the shadows to indicate the branches of leaves. I like to feather my brushstrokes here to give the appearance of leafy branches.

STEP 04

Create a lighter shade of sap green by adding a little white. Repeat the technique from step 2, but try not to cover all the mid-tone and shadow layers as you want to give an impression of depth.

STEP 05

Using lime green mixed with a little white, use the same feathering technique to add highlights to the top layer of leaves.

Project 46

Wisteria

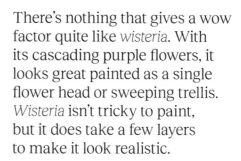

There's nothing that gives a wow factor quite like *wisteria*. With its cascading purple flowers, it looks great painted as a single flower head or sweeping trellis. *Wisteria* isn't tricky to paint, but it does take a few layers to make it look realistic.

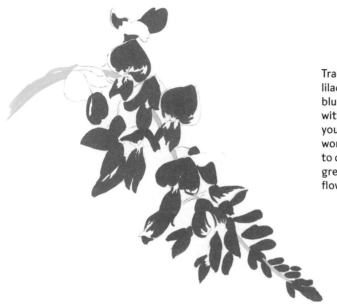

STEP 01

Trace the template on page 237. Mix lilac with a little white and primary blue and fill in the areas, as shown, with a size 1 paintbrush. This will be your base layer and from here you'll work on adding shadow and highlights to create shape and depth. Using lime green and a size 1 brush, block in the flower stem.

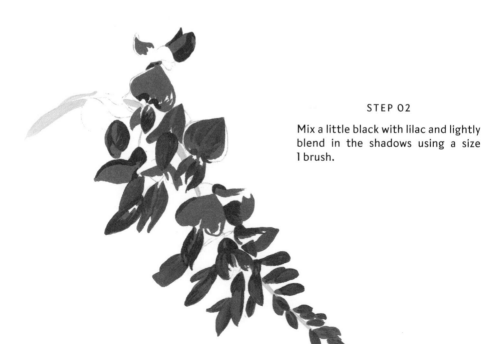

STEP 02

Mix a little black with lilac and lightly blend in the shadows using a size 1 brush.

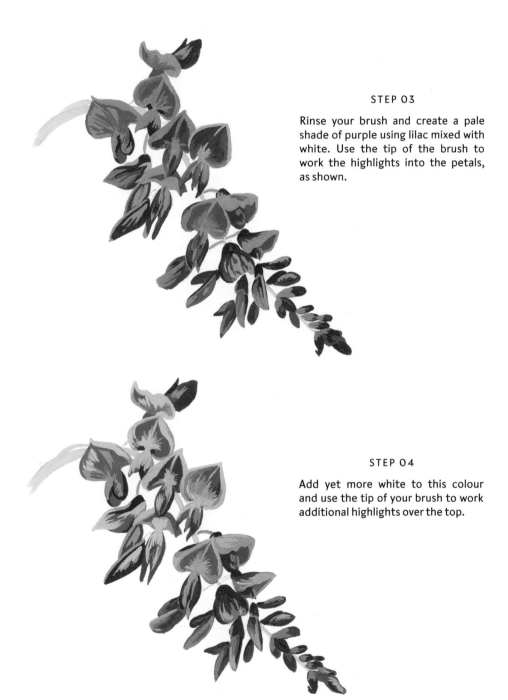

STEP 03

Rinse your brush and create a pale shade of purple using lilac mixed with white. Use the tip of the brush to work the highlights into the petals, as shown.

STEP 04

Add yet more white to this colour and use the tip of your brush to work additional highlights over the top.

Project 47

Autumn Leaf

I can't decide whether my favourite season is autumn or spring. The most beautiful of the seasons, they both feel incredibly different. There's something very melancholy about autumn. The period before nature dies back feels like the last few moments of warmth before the long winter sets in. The colours are spectacular: all reds and oranges and the low sunlight that bathes the leaves in a soft, romantic light.

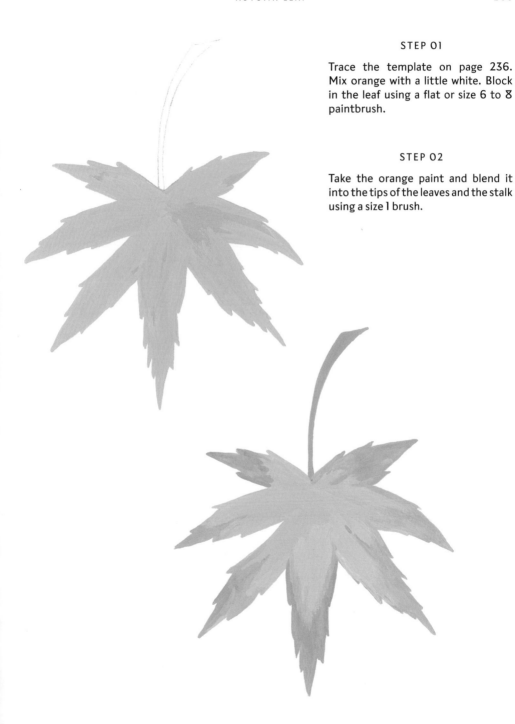

STEP 01

Trace the template on page 236. Mix orange with a little white. Block in the leaf using a flat or size 6 to 8 paintbrush.

STEP 02

Take the orange paint and blend it into the tips of the leaves and the stalk using a size 1 brush.

STEP 03

Mix a little red into the orange and continue to work this into the tips of the leaves. Use the tip of your brush to add flecks of detail and paint in the veins of the leaf.

STEP 04

Finally, mix a little Vandyke brown into the orange mix from step 3 and add fine detail to a few of the leaf tips. You might want to add some flecks of detail to the other parts of the leaf too to make it look even more realistic.

Project 48

Orange Tree

I remember one of my first ever trips to Spain as a teen and being in awe of the orange trees lining the streets. They have such a strong association with long, lazy summers for me and whenever I come across photos of Seville in the summer, the smell of those trees comes flooding back.

STEP 01

Trace the template on page 237. Mix together Vandyke brown, white and a little black and block in the tree trunk using a size 3 paintbrush. If you want to add extra bark detail here, mix in a little more white and work this over the top using rough brushstrokes.

STEP 02

Mix willow green with a little black and use a flat wash brush to block out the canopy of the tree. Allow this layer to dry for a few minutes.

STEP 03

Using sap green and a size 3 brush, work feathered brushstrokes over the shadows to call out the green branches. Feel free to drag little tendrils down at the edges of the branches, which gives the tree more of a wild, natural feel.

STEP 04

Repeat step 3 using lime green. Try not to cover all the mid-tone and shadow layers as you want to give the impression of depth.

STEP 05

Using a size 1 brush and orange paint, dot circles among the leaves. While you wait for these to dry, mix a little white into the orange, then paint over the top of the orange base layer. Then add small flecks of white to the oranges to indicate little reflections of sunlight.

STEP 06

Add white to the lime green and add a few more leaves to the top layer. You may want to paint a few overlapping a couple of oranges to give the impression that the oranges are nestled among the leaves.

Project 49

Water Lily

When I first took up painting, I booked my first ever painting retreat to encourage myself to keep going. I packed up my paints and my tiny painting table and stayed for one night at a pond house in the middle of nowhere. It turned out to be the best place to find inspiration! The water lilies were in full bloom, but it wasn't until I started painting them that I realised the lily pads were almost as ornate as the flowers! I've kept them both simple here, but if you want to spend longer than 15 minutes, try experimenting by adding more detail to the leaves - the results are wonderful!

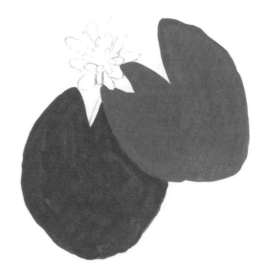

STEP 01

Trace the template on page 236. Mix together sap green, primary blue and a little black and block in the bottom lily pad using a size 3 to 6 paintbrush. Mix together sap green with a little yellow ochre and block in the top lily pad.

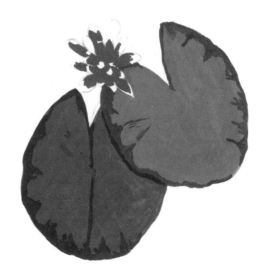

STEP 02

Add a little more black and blue to the green, blue and black mix, then use a size 1 brush to blend shadows into the edges of the bottom leaf. Bring these in towards the centre a little to give the impression of slightly rippled edges. Repeat for the top leaf by working a little Vandyke brown into the sap green and yellow ochre shade. Using a rose pink and a fine brush (size 1 or smaller), paint in the shadowed areas of your water lily.

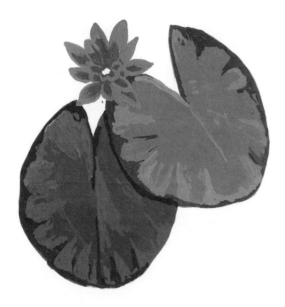

STEP 03

Add a little white to both shades of green and, using a size 1 brush, start blending highlights into the outer areas of the lily pads. Mix a little white or peach into the rose pink you used in step 2 and lightly fill in the negative space left for the highlights, as shown.

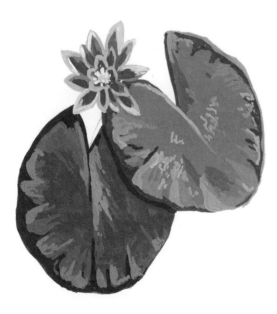

STEP 04

Finally, add a little more white and sap green to the bottom lily pad by blending into the highlights. Repeat for the top lily pad, but use the very tip of your brush to add fine lines and detail. Add more white to the light pink tint and outline the edges of the water lily petals.

Project 50

Leaf Branch

Sometimes, keeping a painting simple can be more impactful. Try adding a simple leaf branch onto beautiful stationery for a super-sleek and elegant look.

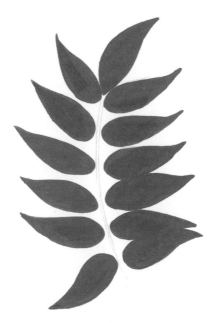

STEP 01

Trace the template on page 237. Fill in the leaves using sap green and a size 1 paintbrush.

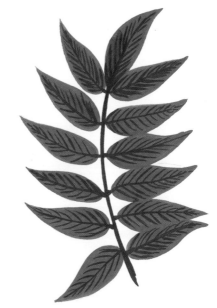

STEP 02

Add the veins of the leaves using sap green mixed with a small amount of black. Use this colour to fill in the stem, too.

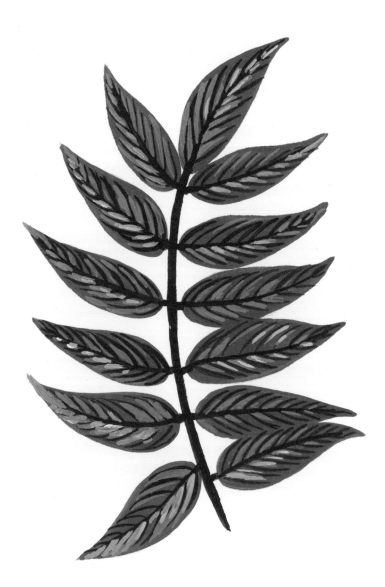

STEP 03

Add a little white to the sap green and lightly brush the colour between the leaf veins. Add a little more white to the sap green mix and dab this lighter tint into the leaves to make them look healthy and glossy.

01.

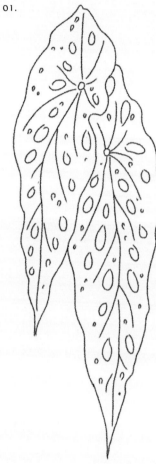

04.

07.

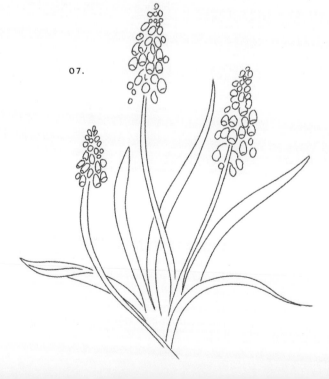

01. BEGONIA LEAF
02. FORGET-ME-NOTS
03. CHINESE MONEY PLANT
04. BRACKEN FERN
05. WILDFLOWERS
06. MIMOSA
07. MUSCARI

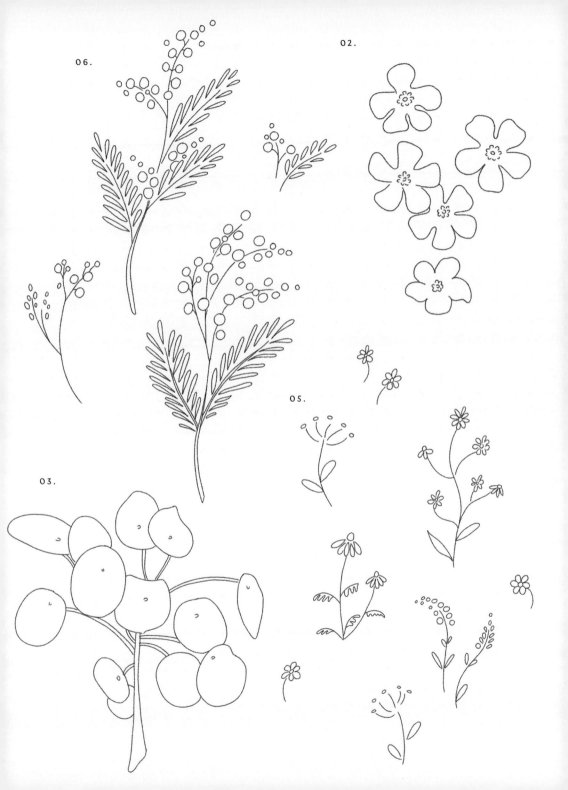

08.

09.

12.

13.

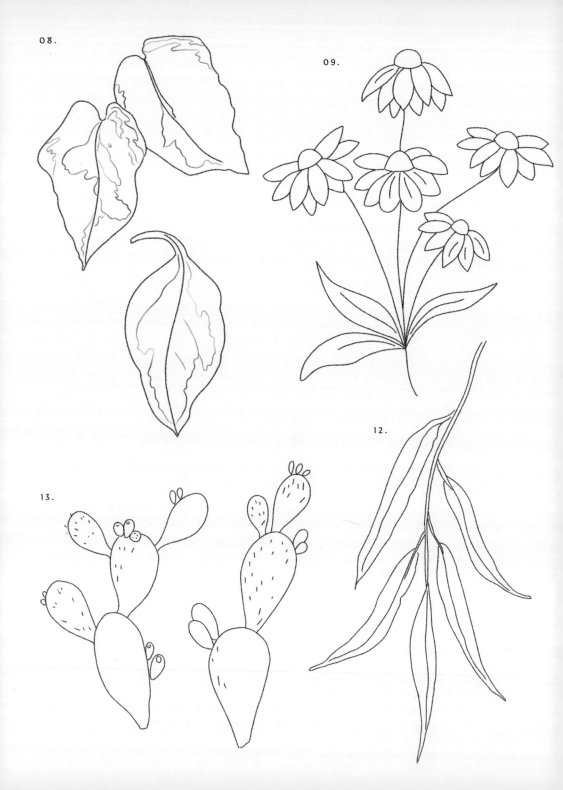

14.

10.

11.

08. VARIEGATED LEAVES
09. ECHINACEA
10. FOXGLOVES
11. FRITILLARIA
12. WILLOW LEAF
13. PRICKLY PEAR CACTUS
14. FAIRY TALE TOADSTOOL

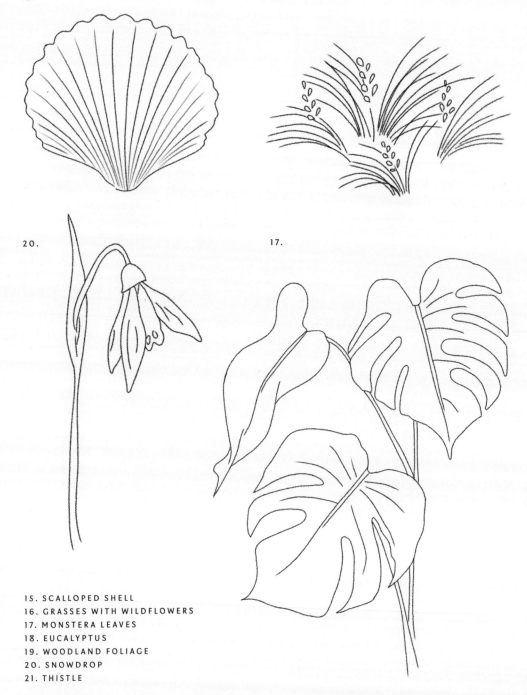

15.

16.

20.

17.

15. SCALLOPED SHELL
16. GRASSES WITH WILDFLOWERS
17. MONSTERA LEAVES
18. EUCALYPTUS
19. WOODLAND FOLIAGE
20. SNOWDROP
21. THISTLE

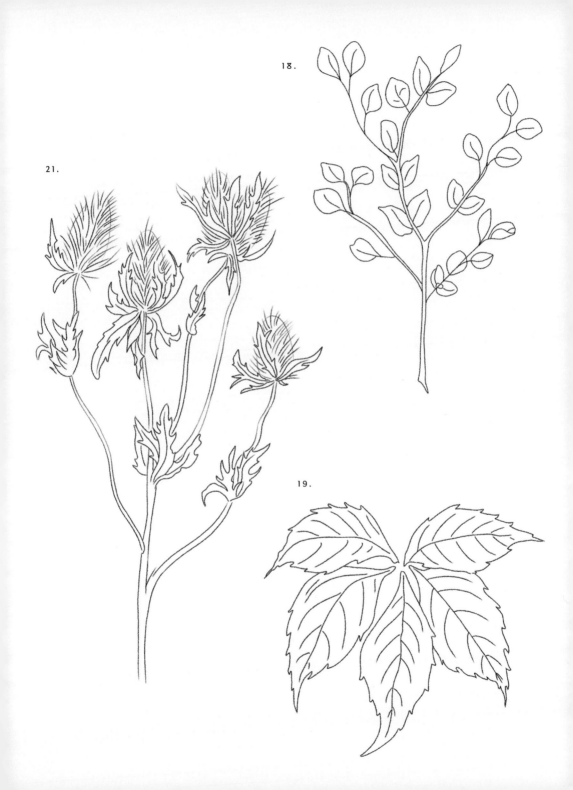

18.

21.

19.

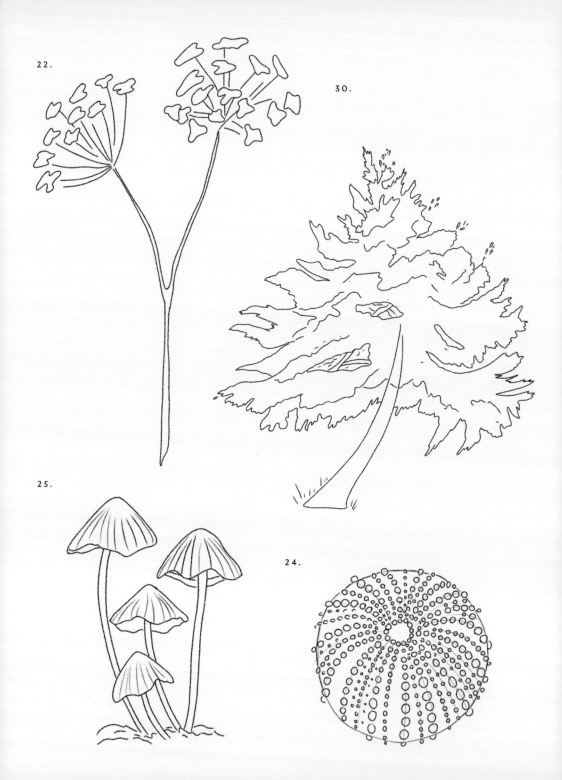

22.

30.

25.

24.

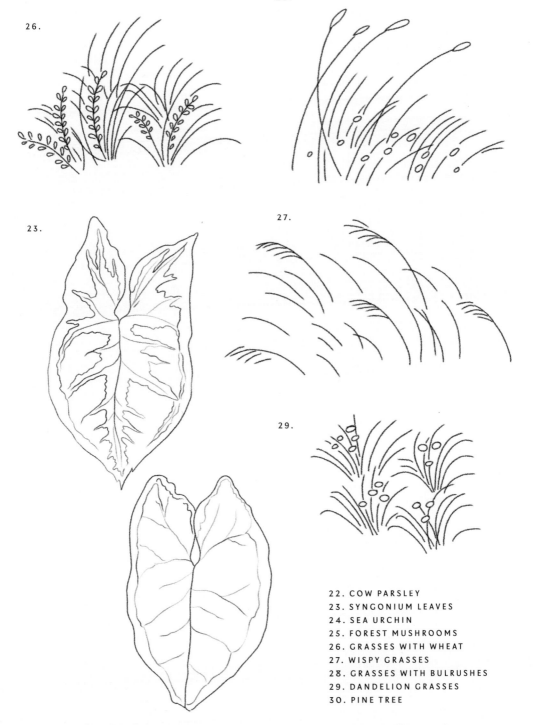

26.

28.

23.

27.

29.

22. COW PARSLEY
23. SYNGONIUM LEAVES
24. SEA URCHIN
25. FOREST MUSHROOMS
26. GRASSES WITH WHEAT
27. WISPY GRASSES
28. GRASSES WITH BULRUSHES
29. DANDELION GRASSES
30. PINE TREE

36.

33.

37.

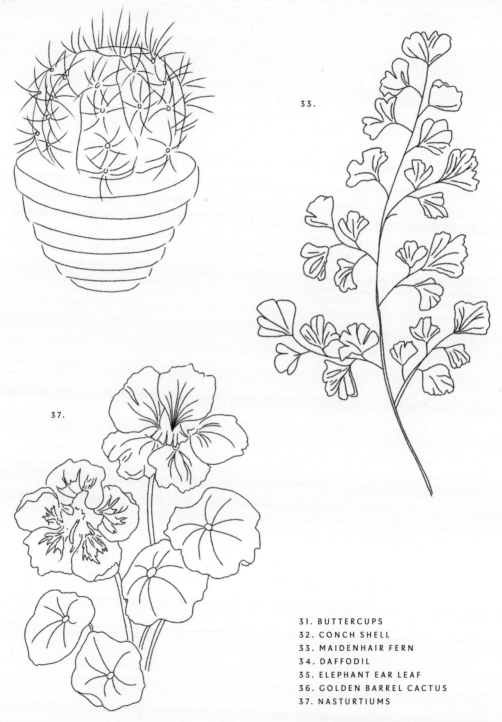

31. BUTTERCUPS
32. CONCH SHELL
33. MAIDENHAIR FERN
34. DAFFODIL
35. ELEPHANT EAR LEAF
36. GOLDEN BARREL CACTUS
37. NASTURTIUMS

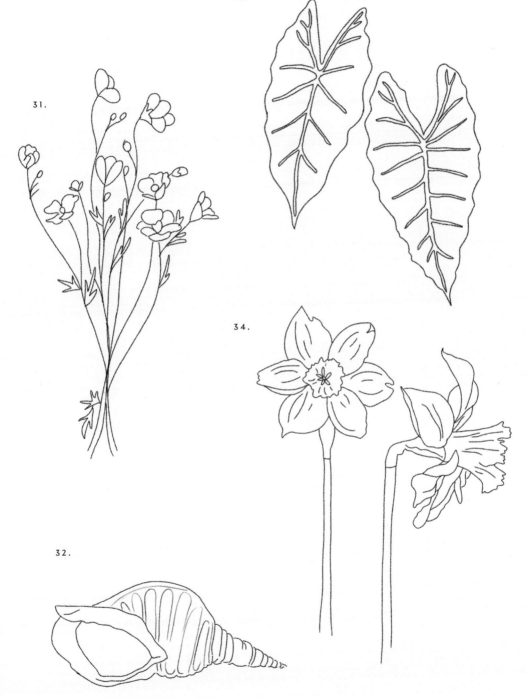

35.

31.

34.

32.

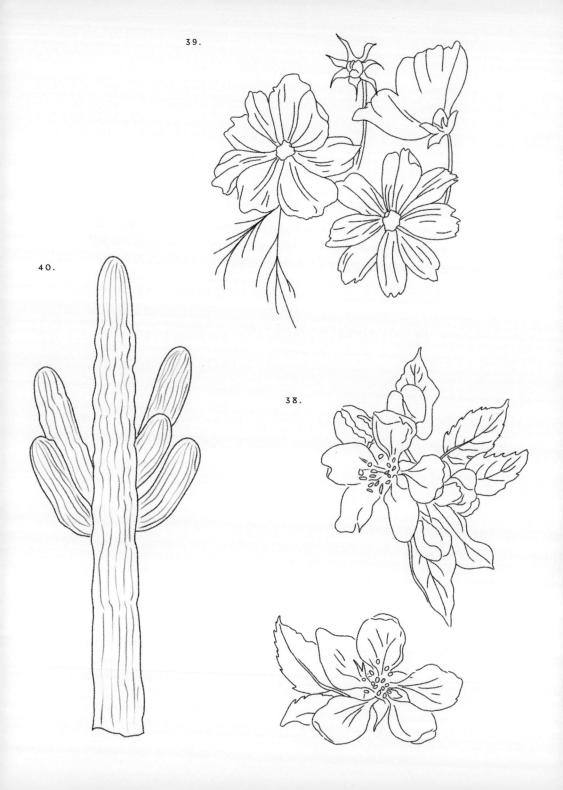

39.

40.

38.

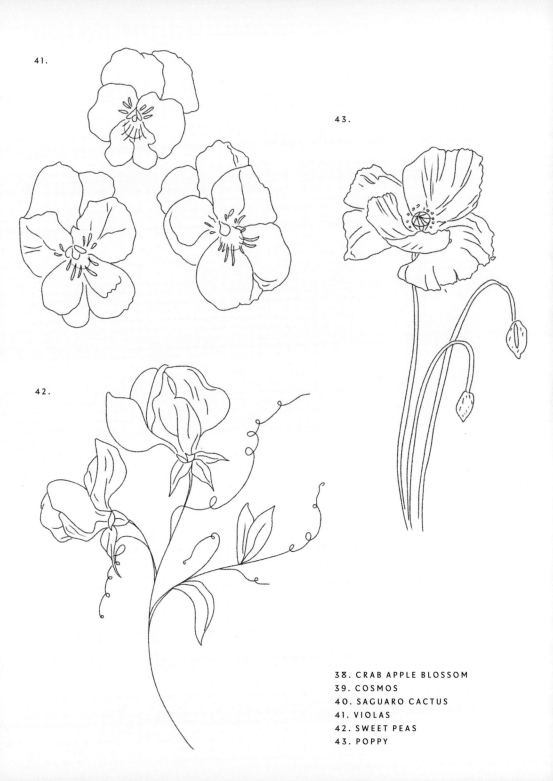

41.

42.

43.

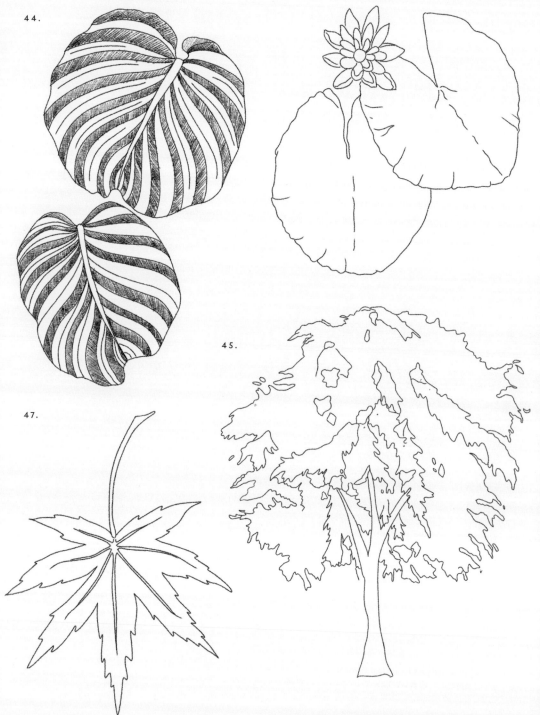

44.

49.

45.

47.

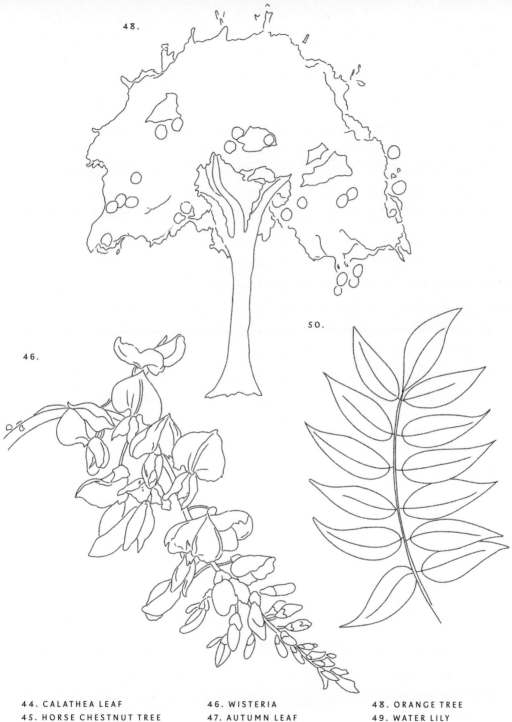

48.

50.

46.

44. CALATHEA LEAF
45. HORSE CHESTNUT TREE

46. WISTERIA
47. AUTUMN LEAF

48. ORANGE TREE
49. WATER LILY
50. LEAF BRANCH

About
the *Author*

Hannah Podbury was born in England and began her foray into painting during lockdown in 2020. Finding solace and inspiration in the surrounding nature of her home in Bedfordshire, she picked up a paintbrush and taught herself to paint. Since then, she's continued to paint almost every day, sharing her stunning nature scenes and sketchbooks on her Instagram, and inspiring others to get started with gouache.

Acknowledgements

I'd like to say thank you to my editor Kate for taking me on this incredible journey and allowing me such creative freedom. And thank you to Amelia for making my paintings look better than I could ever have imagined!

A special thank you to my Mum and Grandfather, for passing down their love of nature, and to James for always being my biggest cheerleader.

Thank you also to my family for all their encouragement, and to my wonderful friends for being the best support system there is.

Lastly, I'd like to thank everyone who's reached out and encouraged me over the last year – this wouldn't have been possible without all of your kind words.

Published in 2022 by Hardie Grant Books,
an imprint of Hardie Grant Publishing

Hardie Grant Books (London)
5th & 6th Floors
52–54 Southwark Street
London SE1 1UN

Hardie Grant Books (Melbourne)
Building 1, 658 Church Street
Richmond, Victoria 3121

hardiegrantbooks.com

British Library Cataloguing-in-Publication Data.
A catalogue record for this book is available from the British Library.

15-Minute Art Painting
ISBN: 9781784884994

10 9 8 7 6 5 4 3 2 1

Publisher: Kajal Mistry
Commissioning Editor: Kate Burkett
Design and Art Direction: Amelia Leuzzi
Illustrations: Hannah Podbury
Proofreader: Caroline West
Production Controller: Katie Jarvis

Colour reproduction by p2d
Printed and bound in China by Leo Paper Products Ltd.